POP MANGA

CUTE AND CREEPY

COLORING BOOK

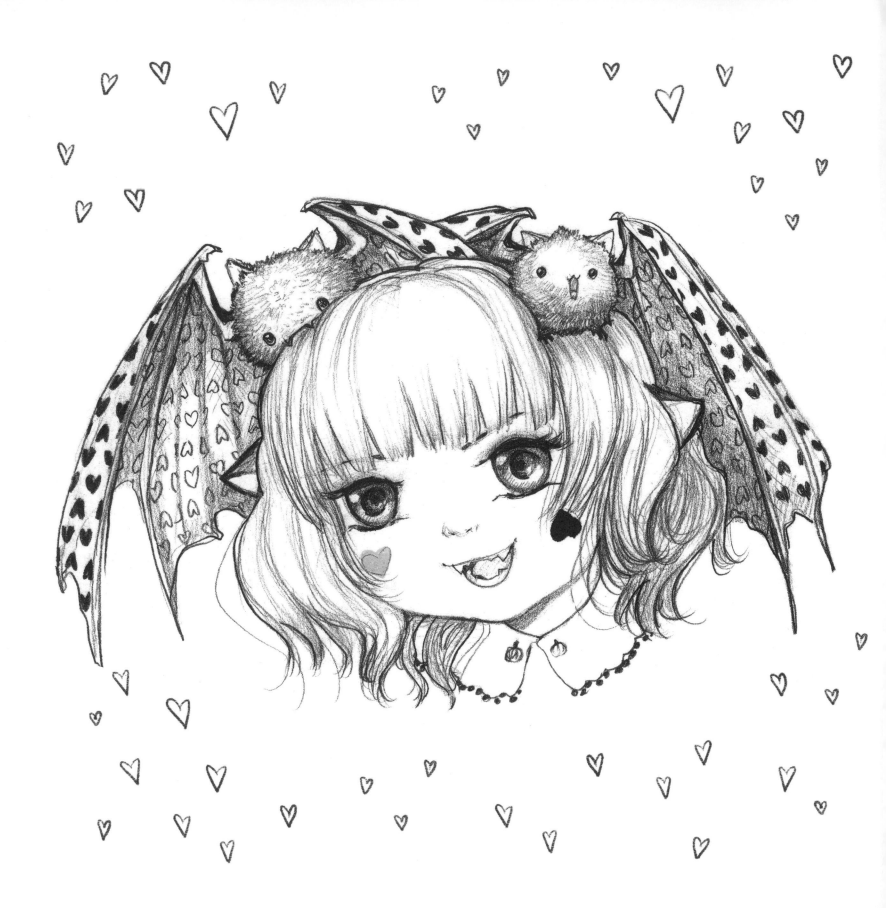

POP MANGA

CUTE AND CREEPY
COLORING BOOK

CAMILLA d'ERRICO

WATSON·GUPTILL
CALIFORNIA | NEW YORK

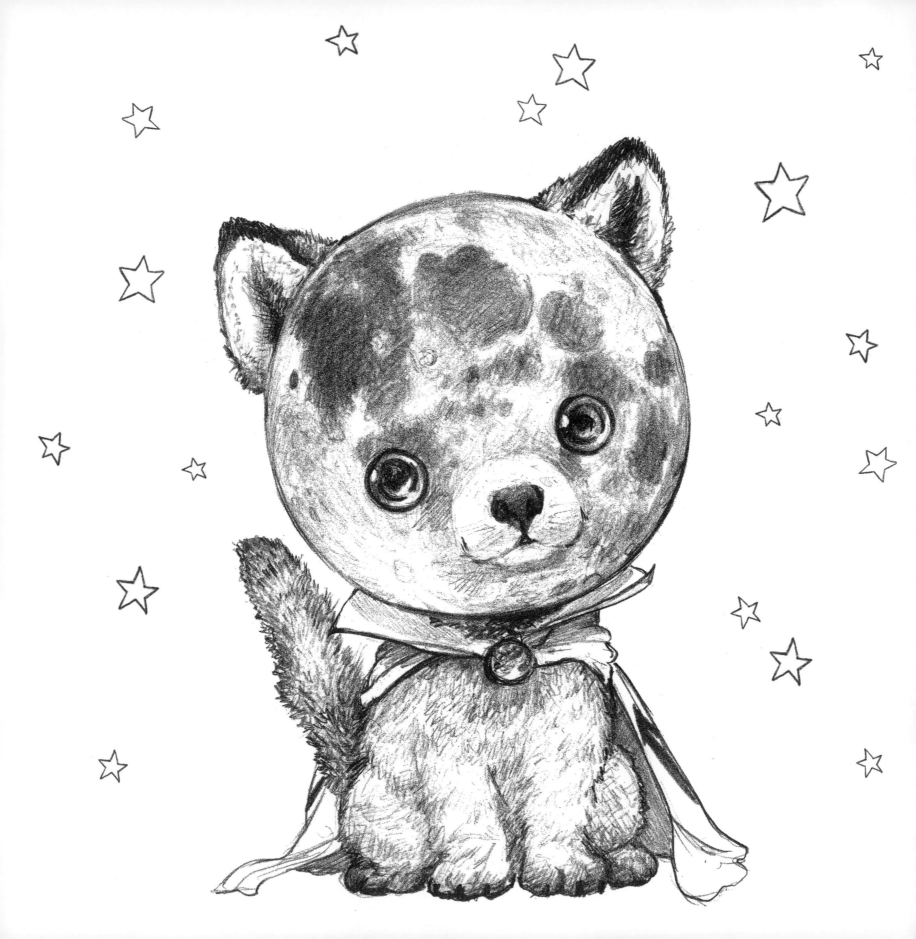

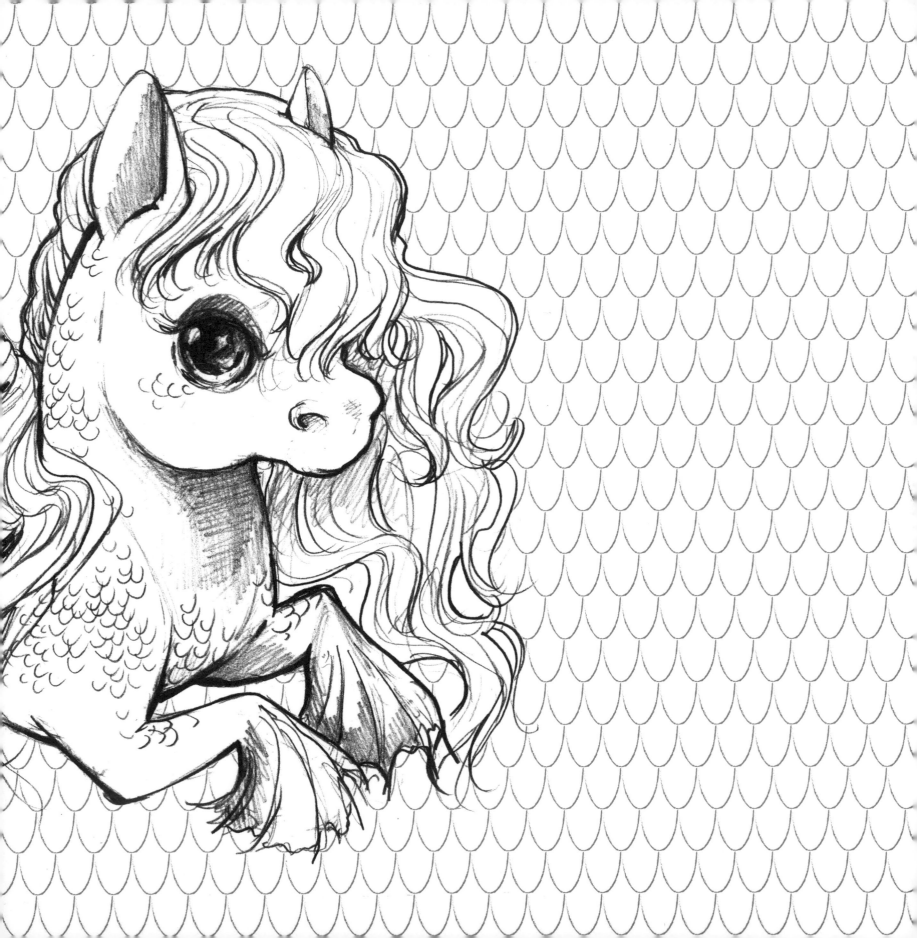

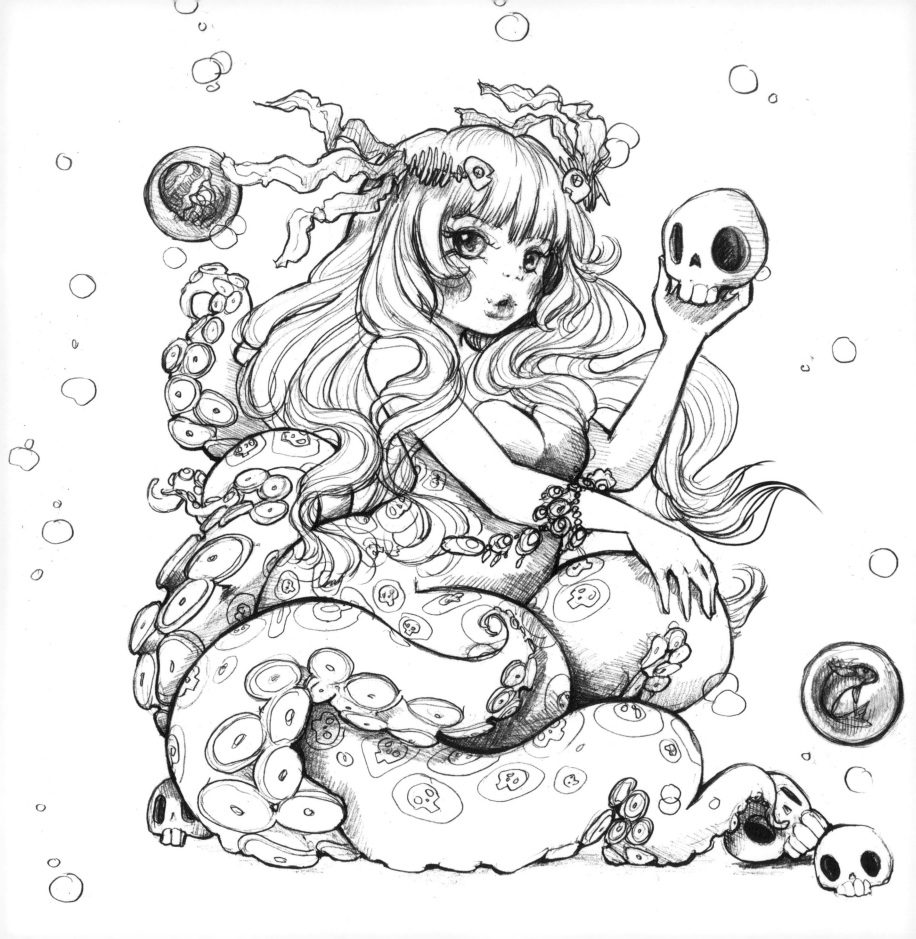

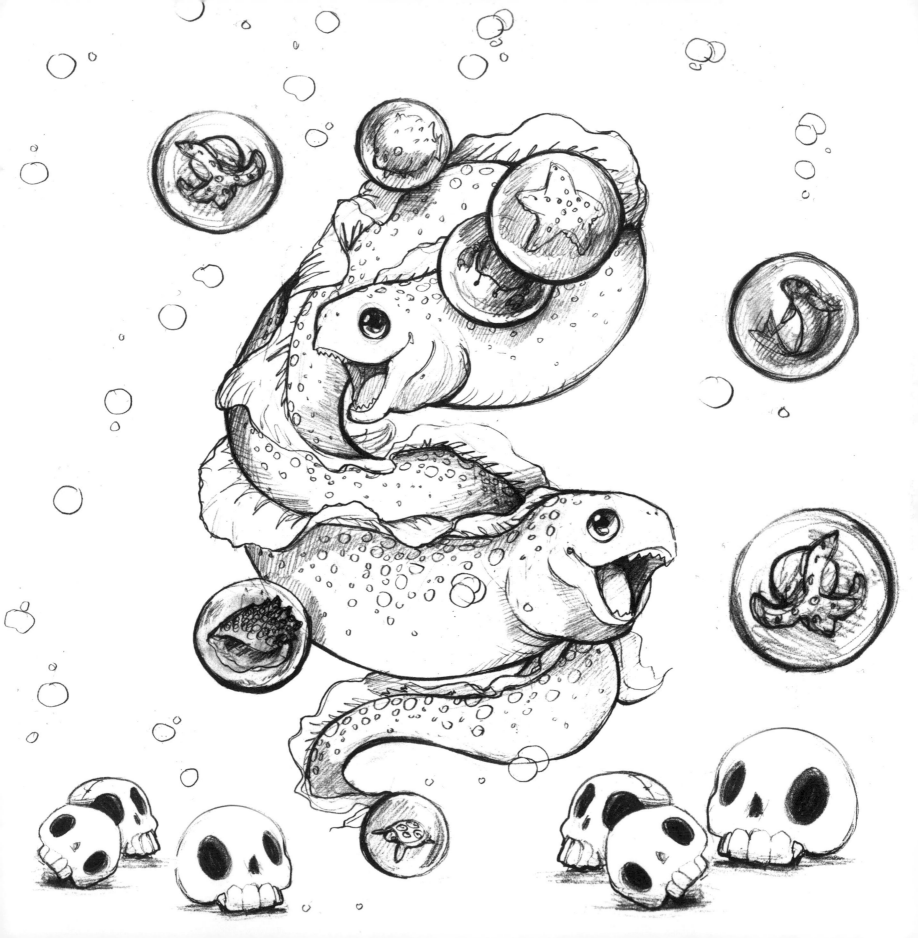

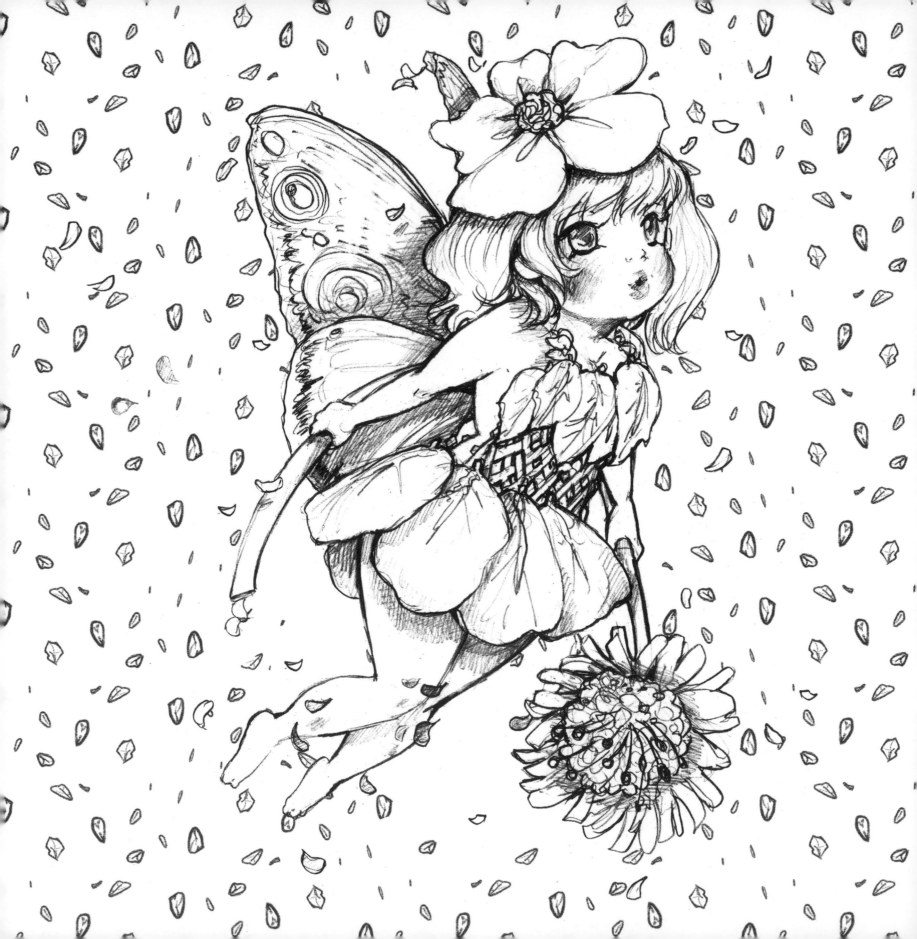

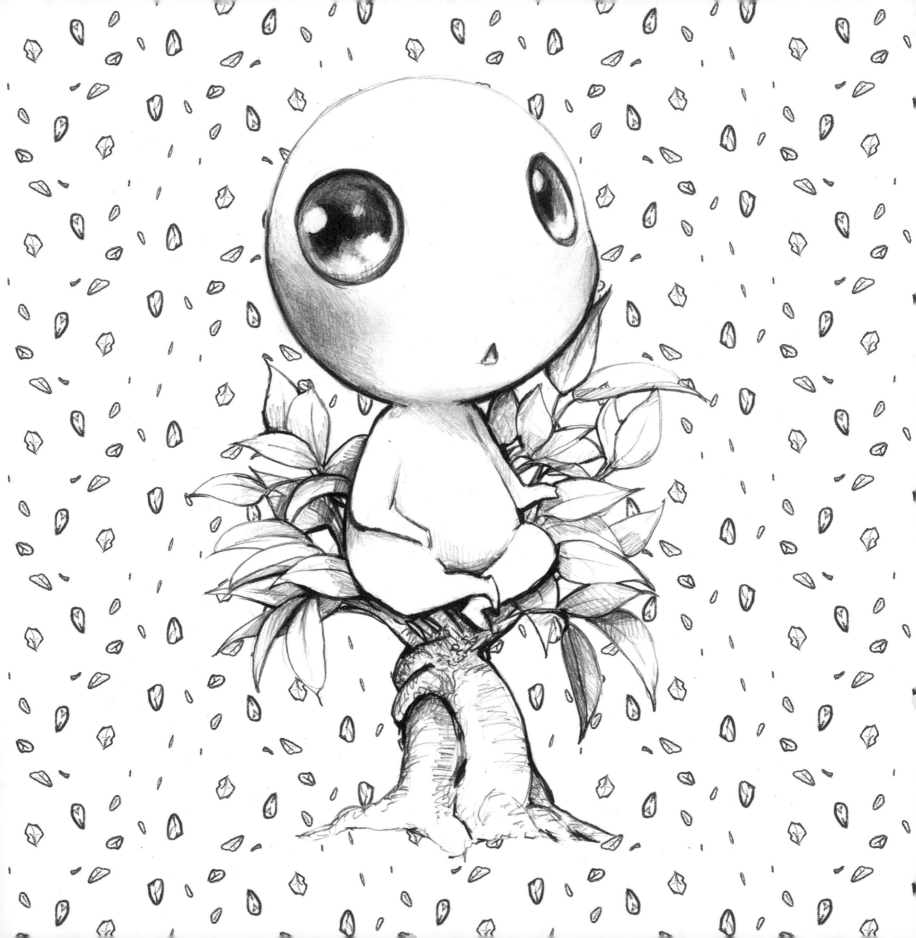

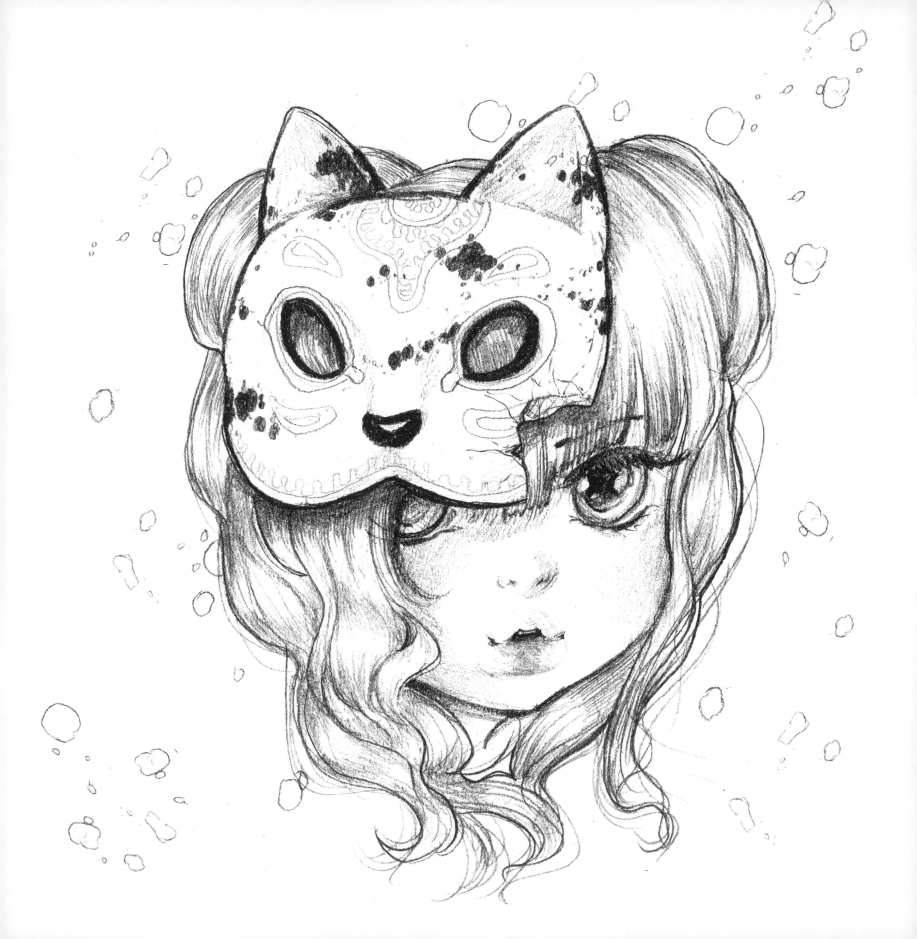

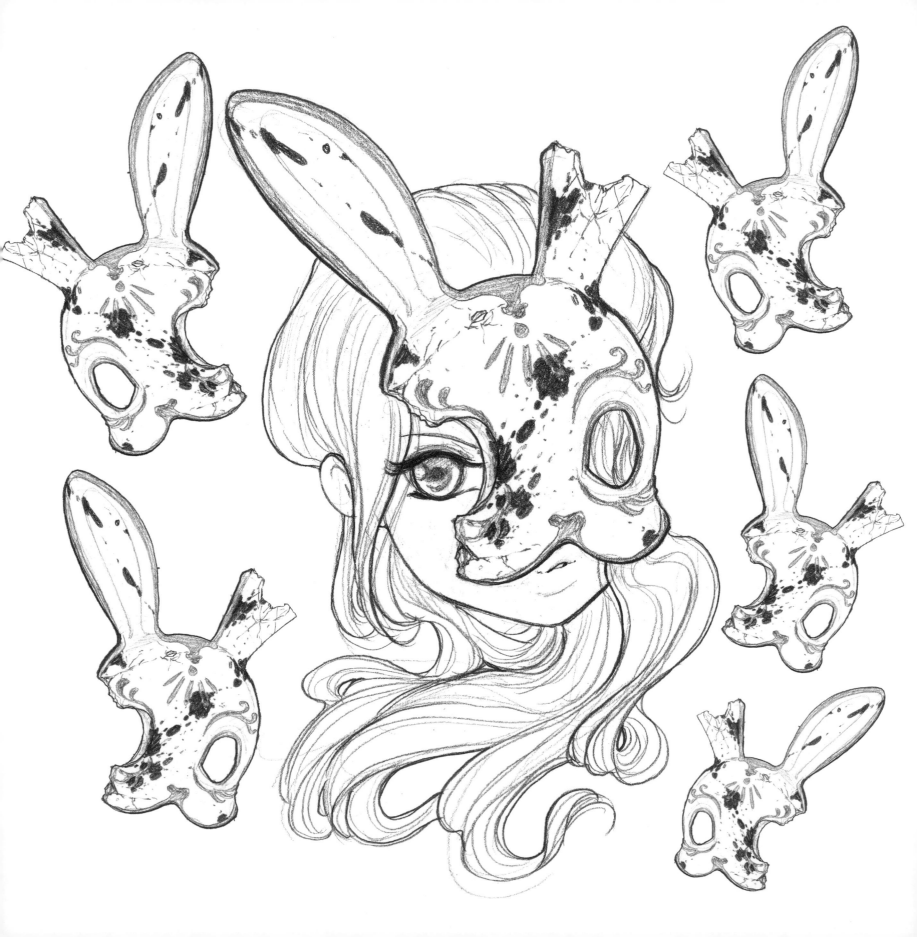

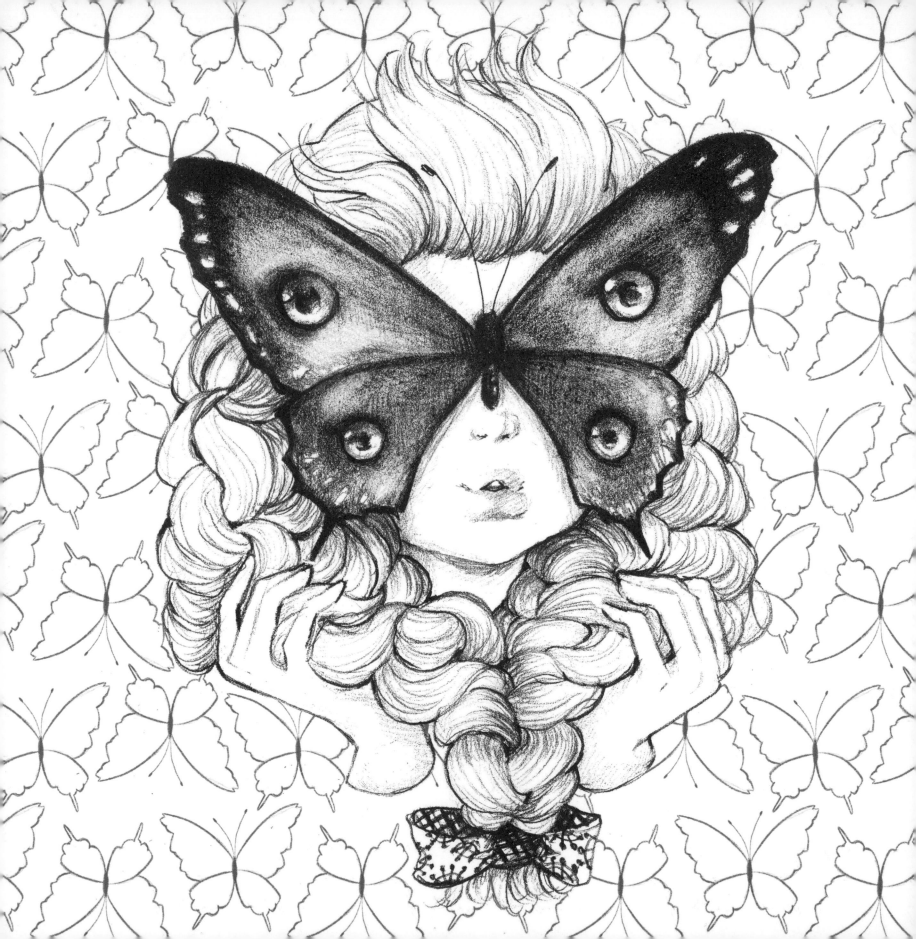

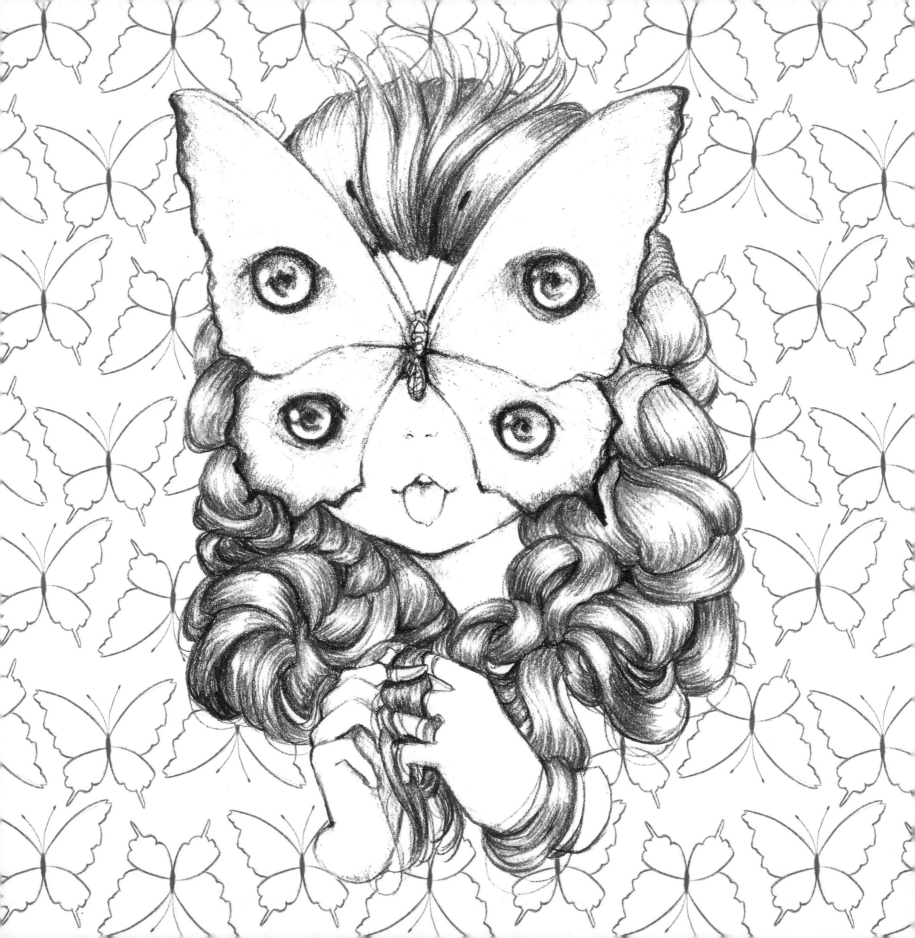

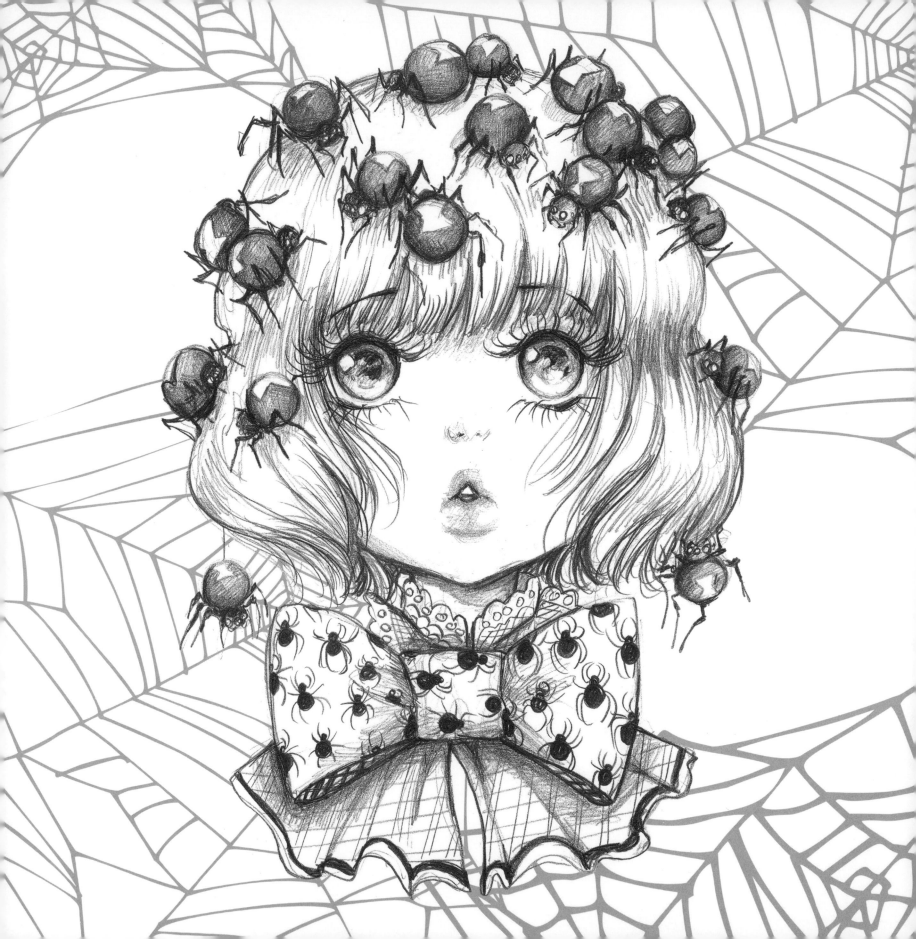

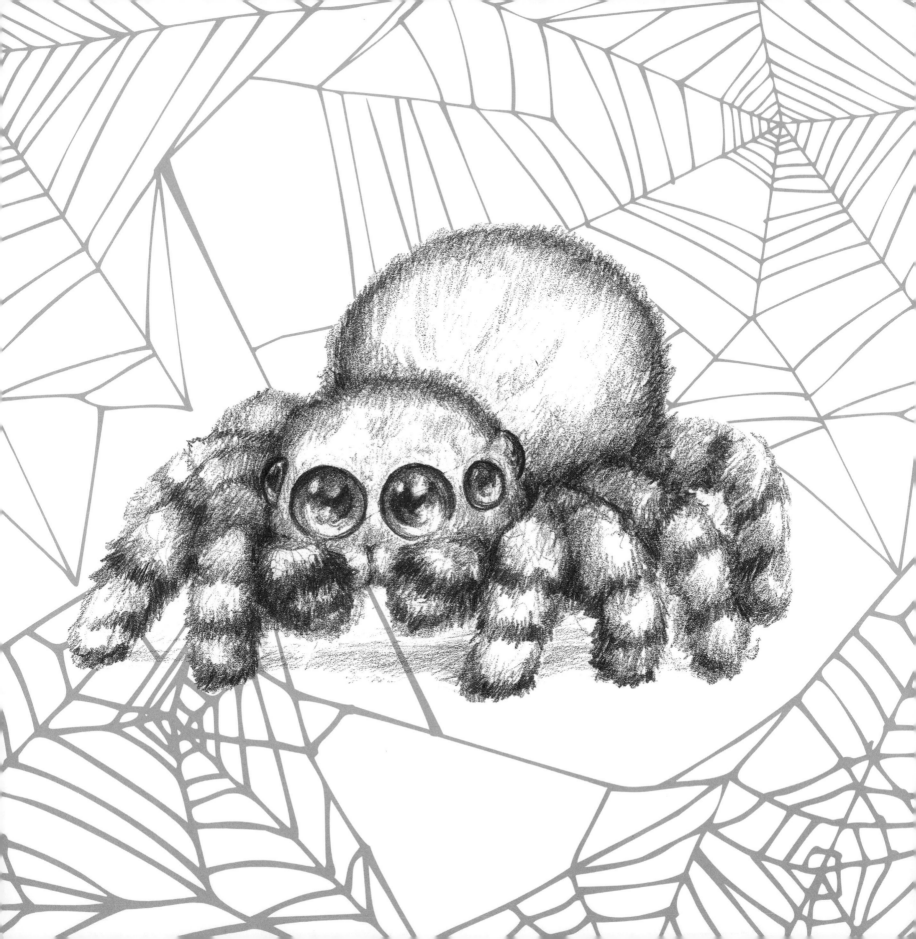

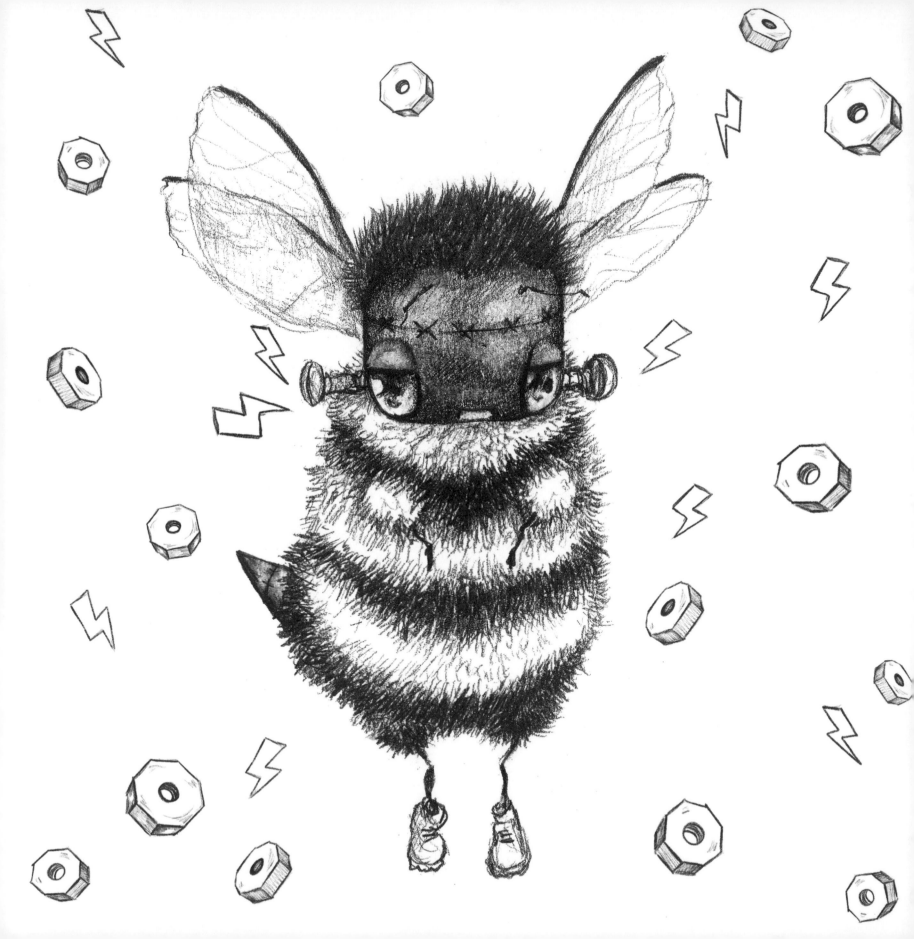

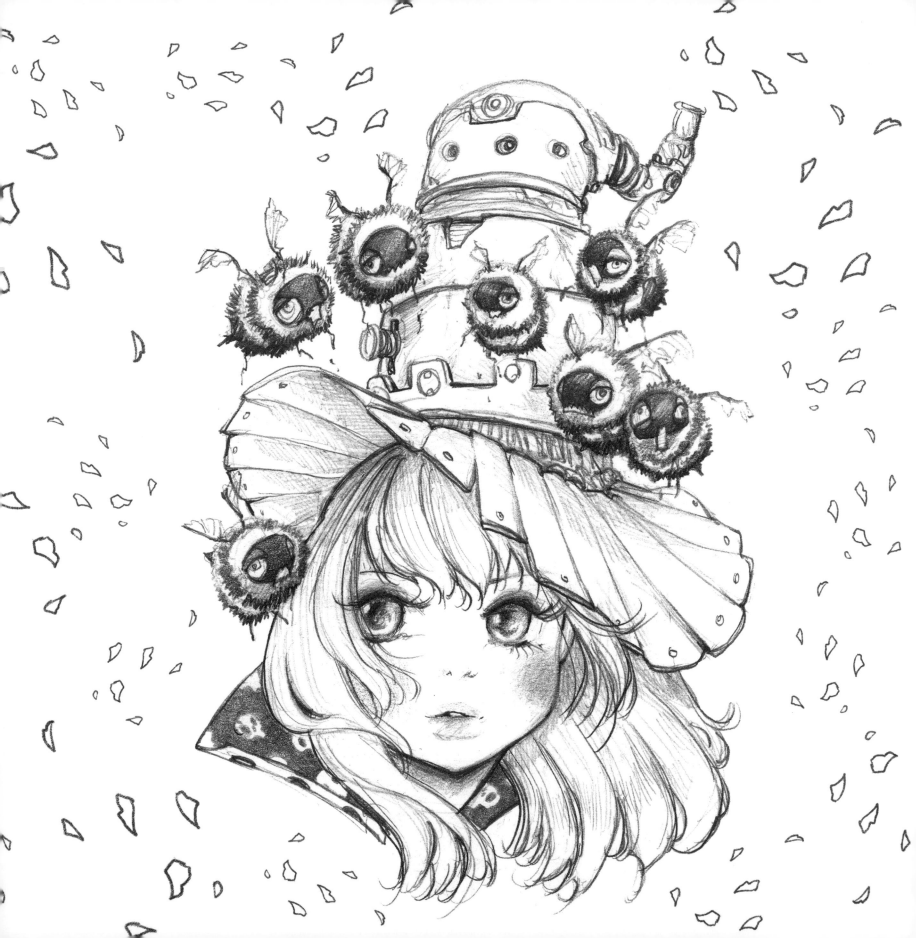

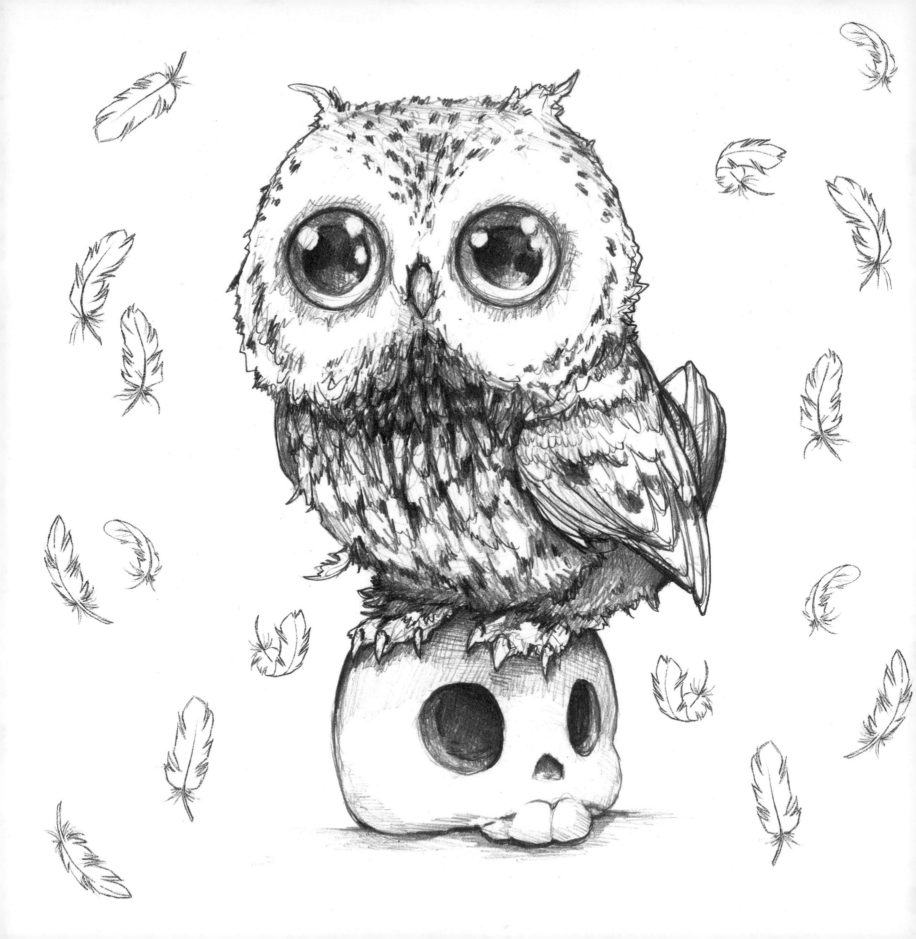

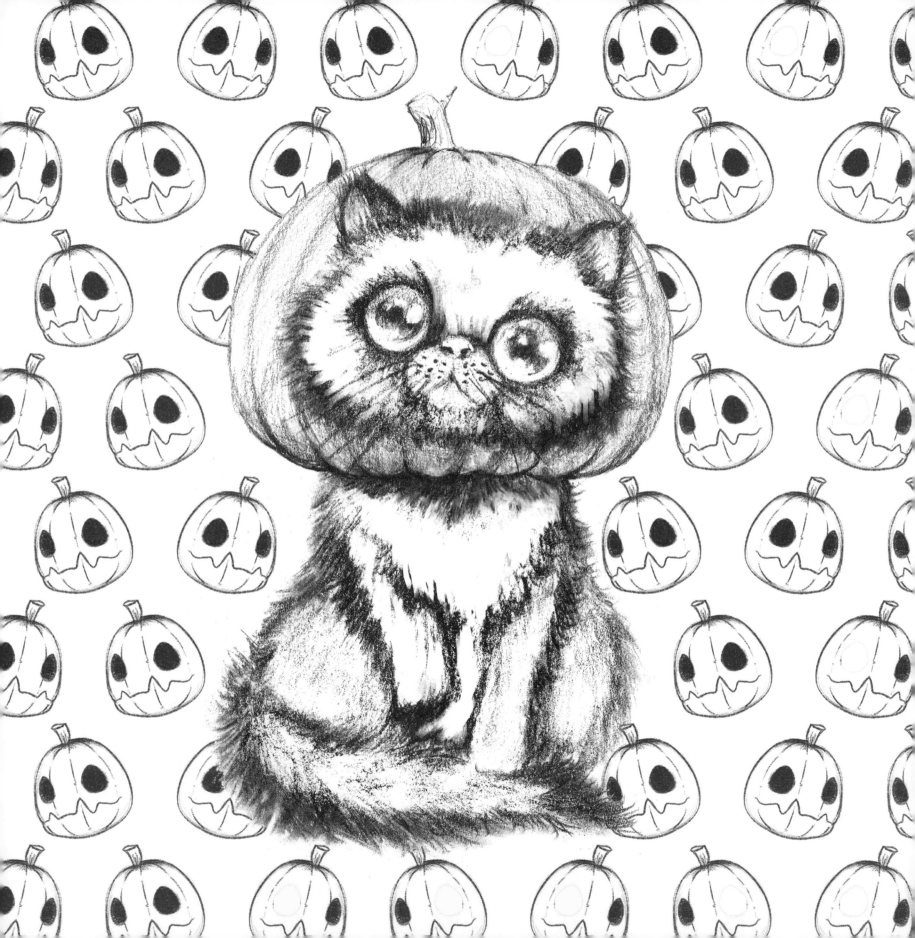

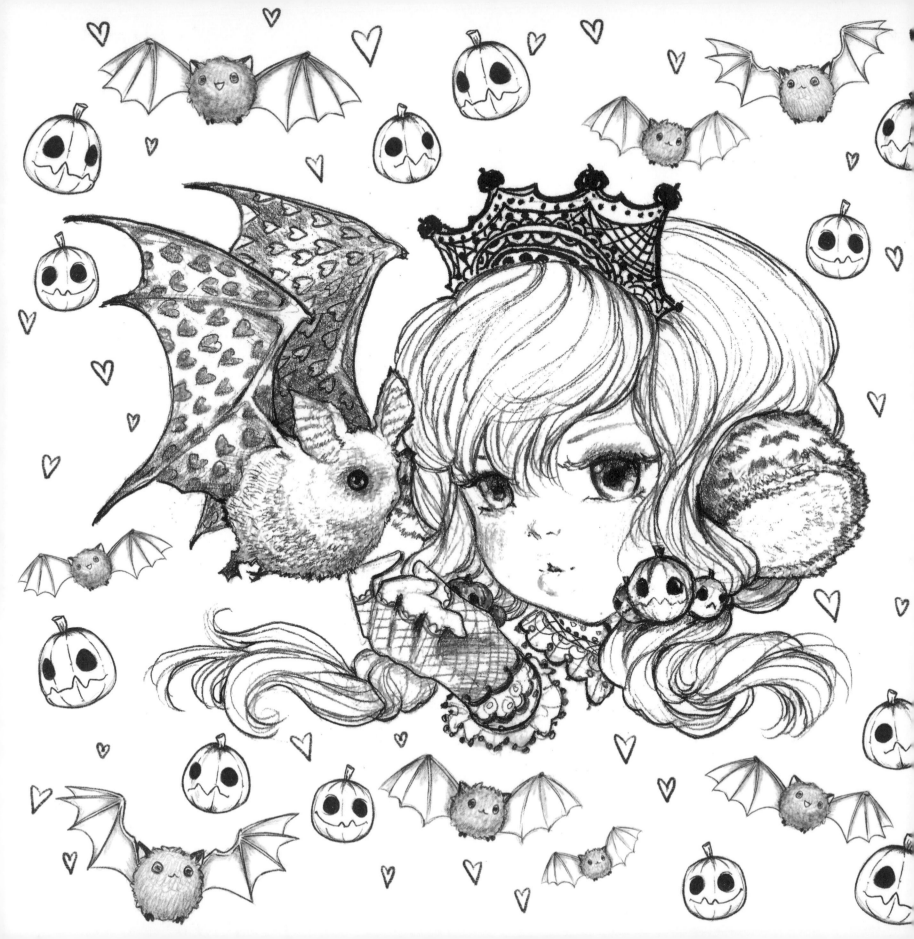

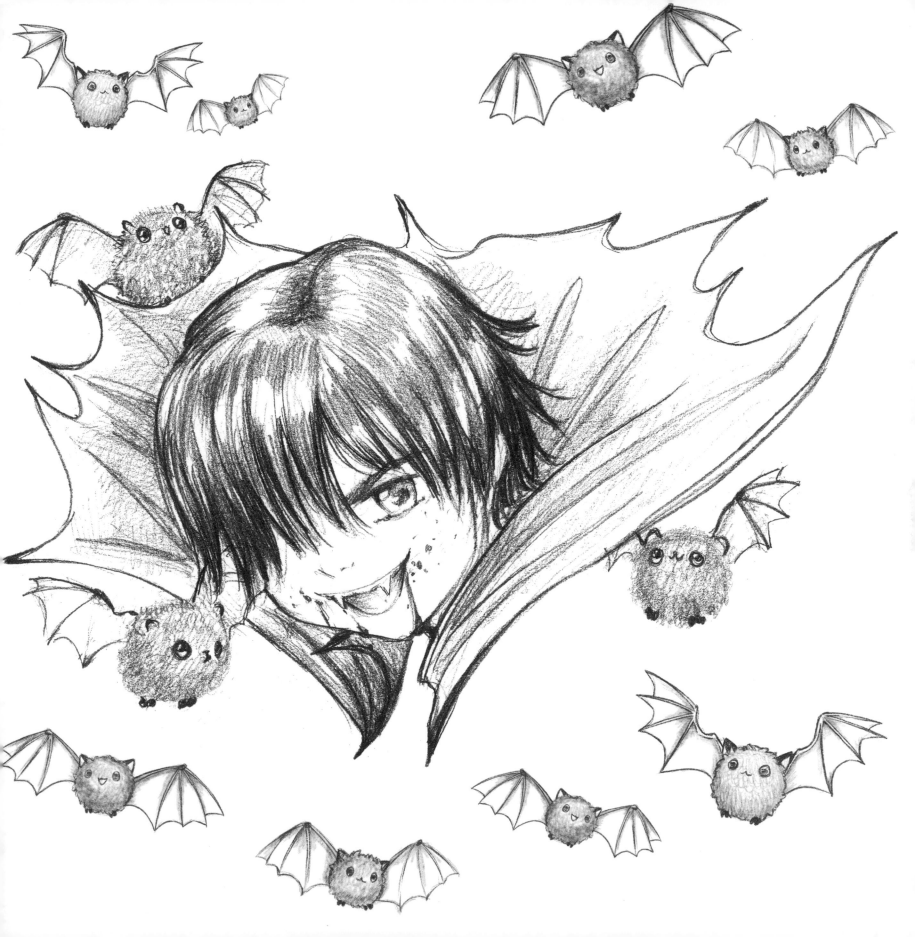

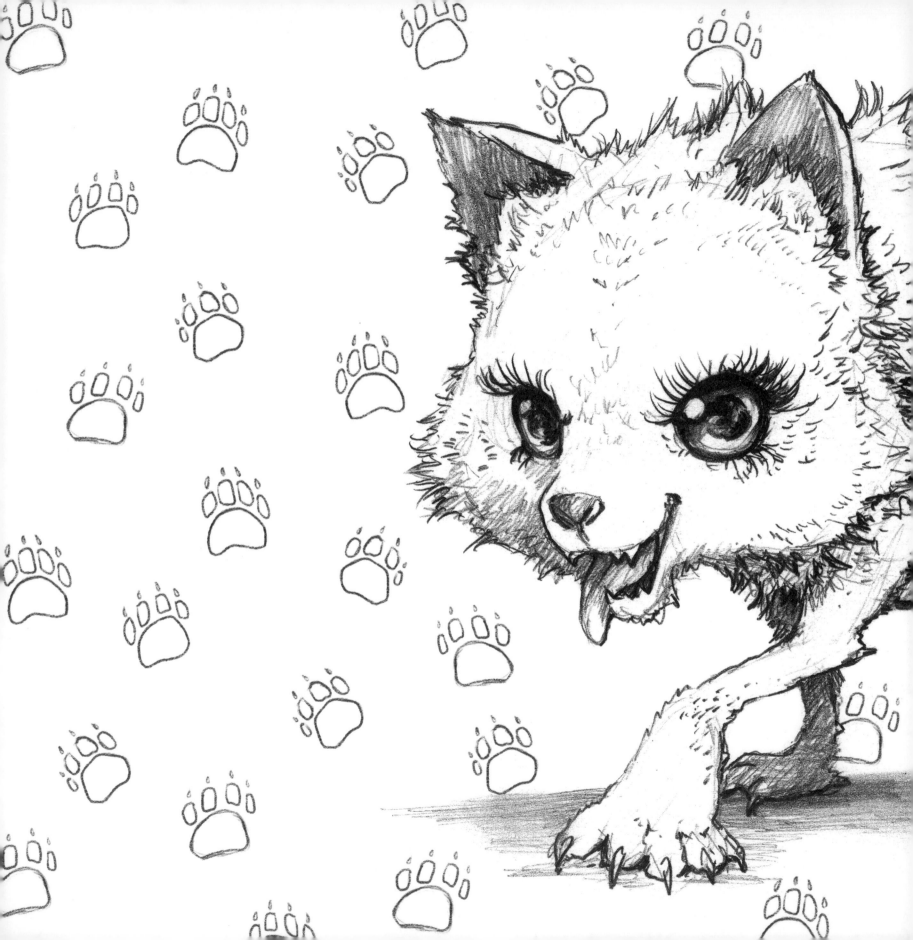

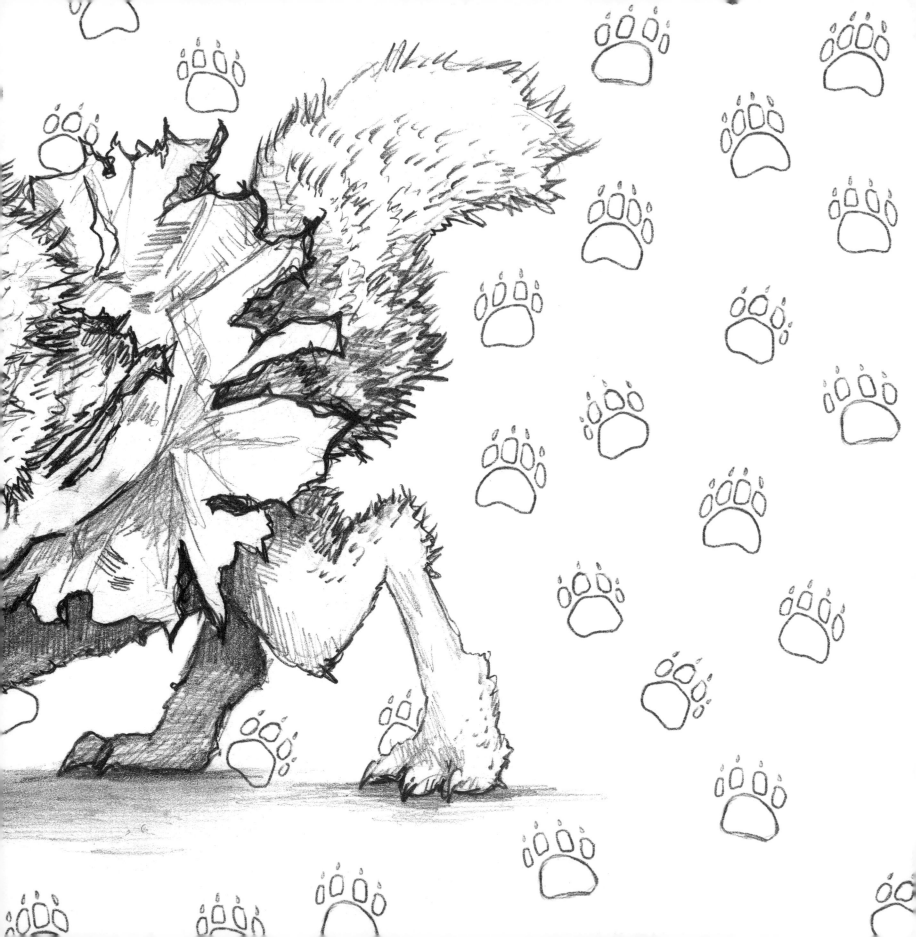

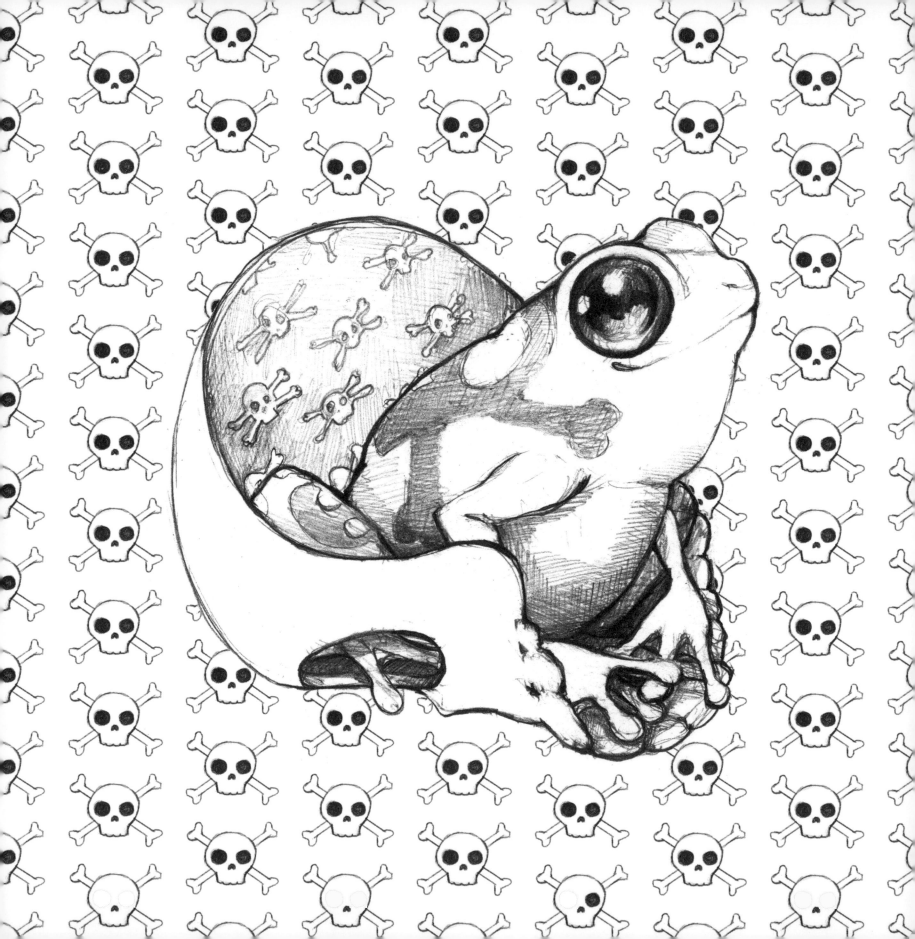

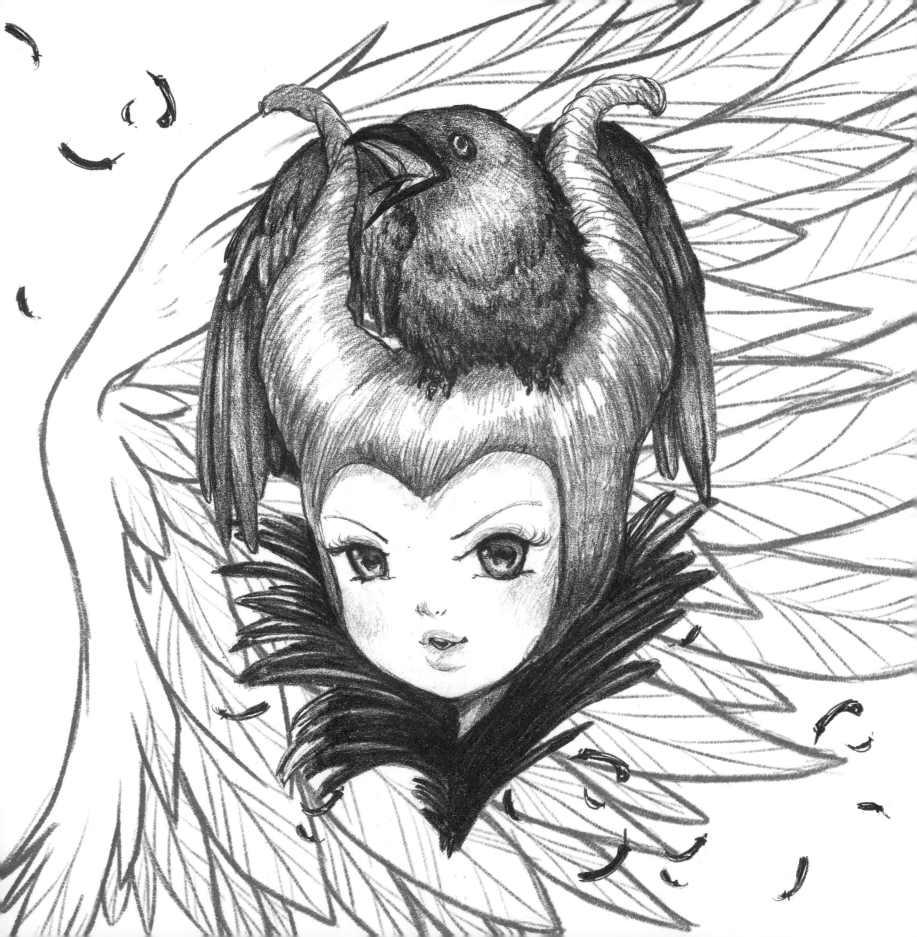

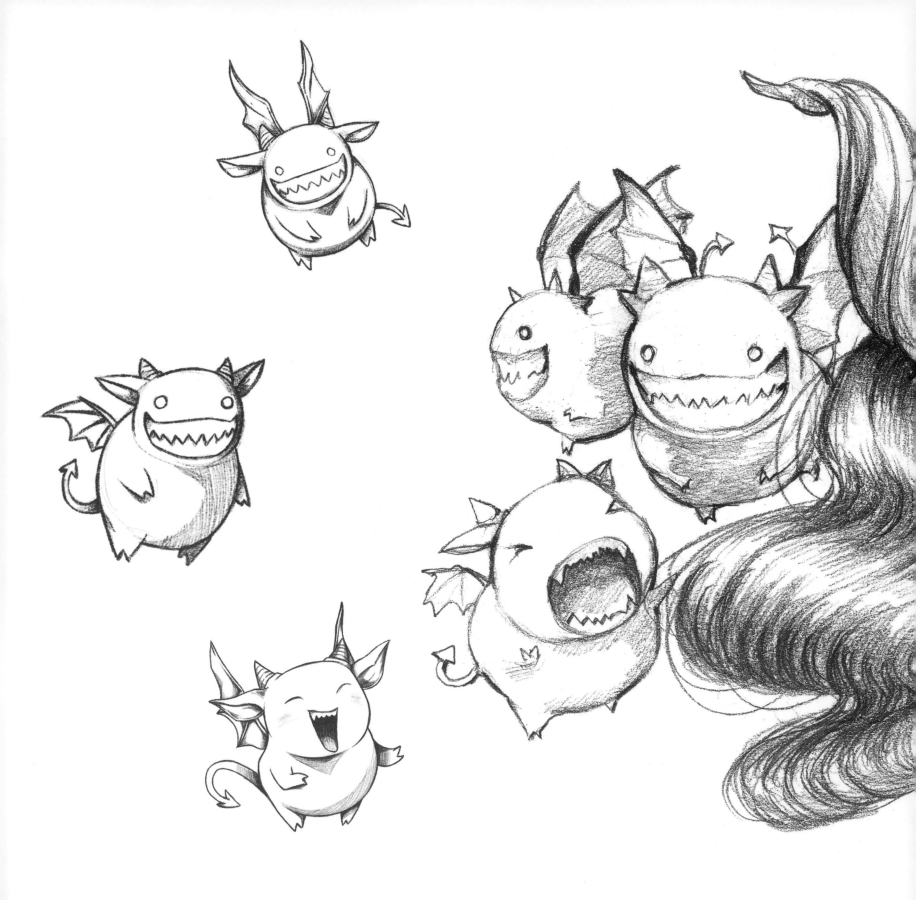

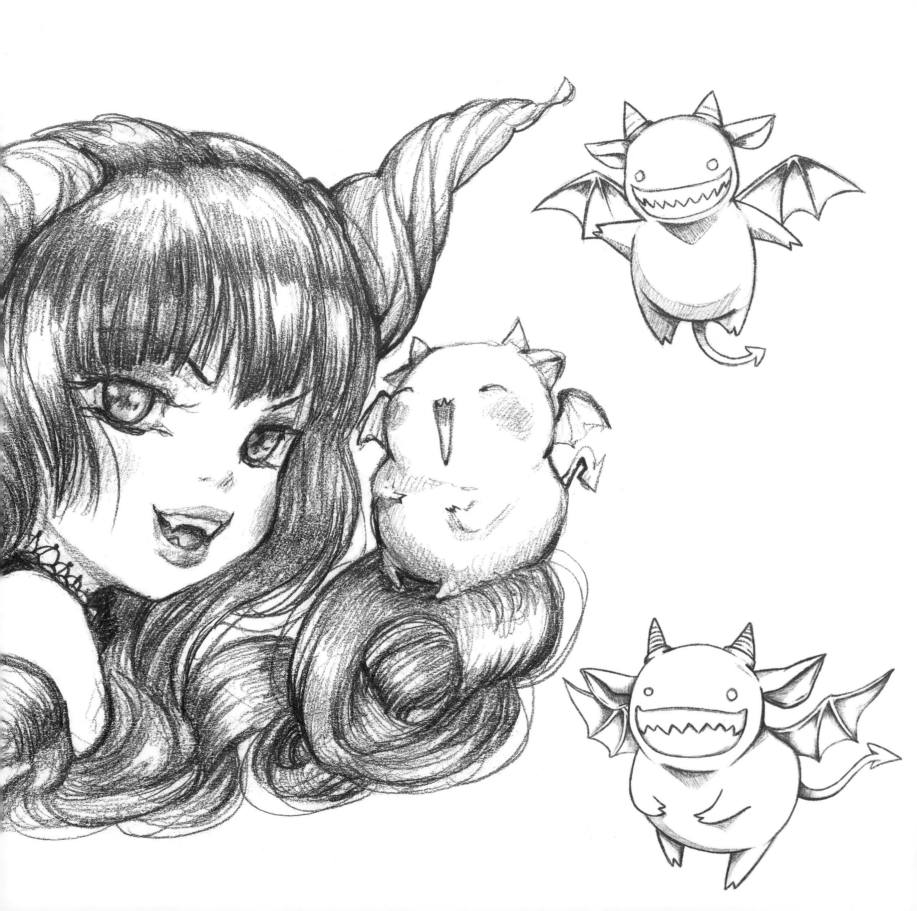

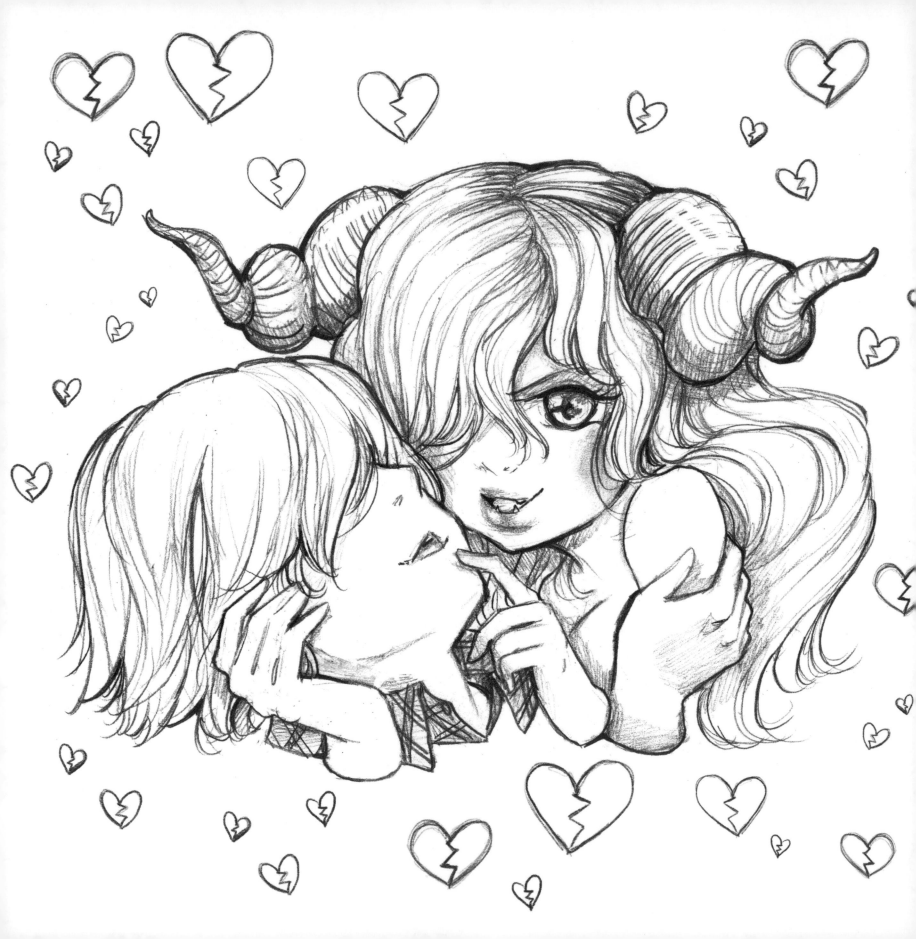

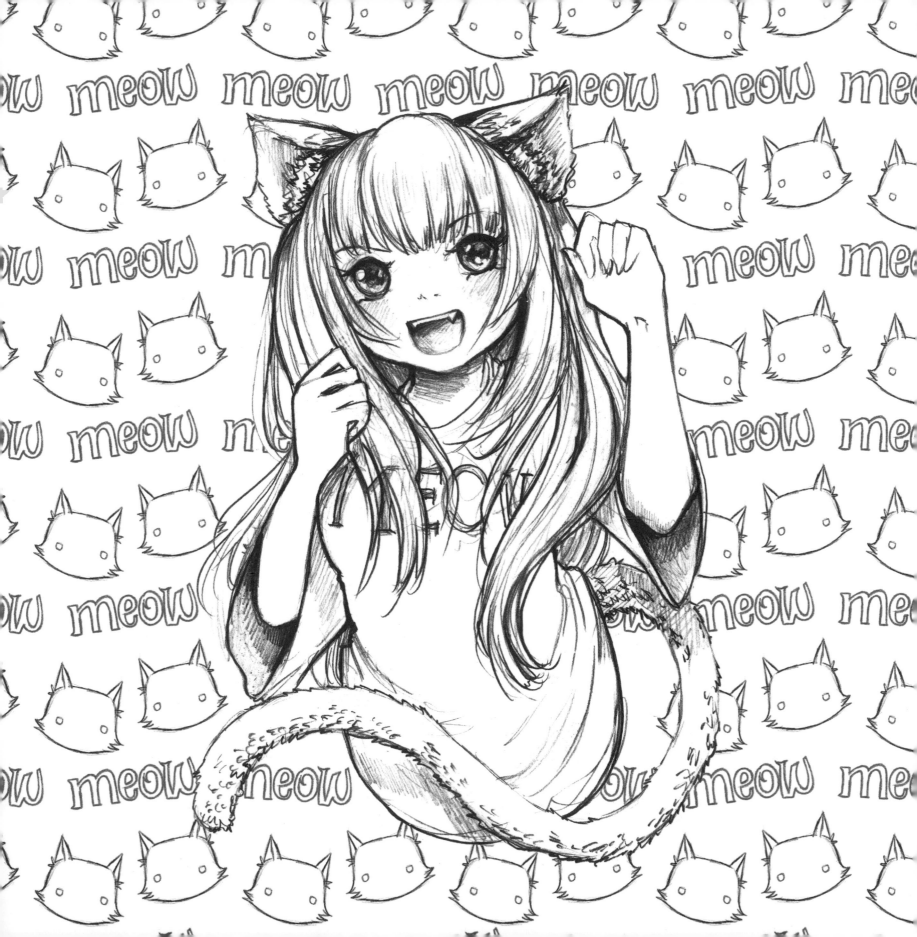

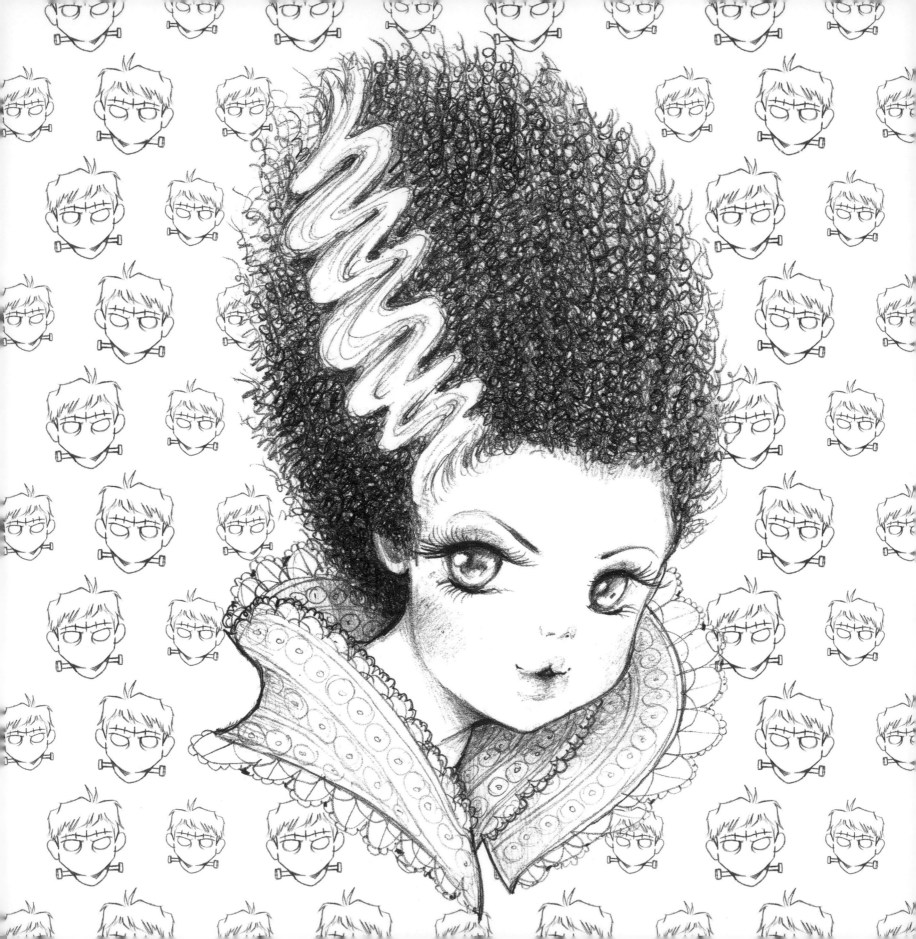

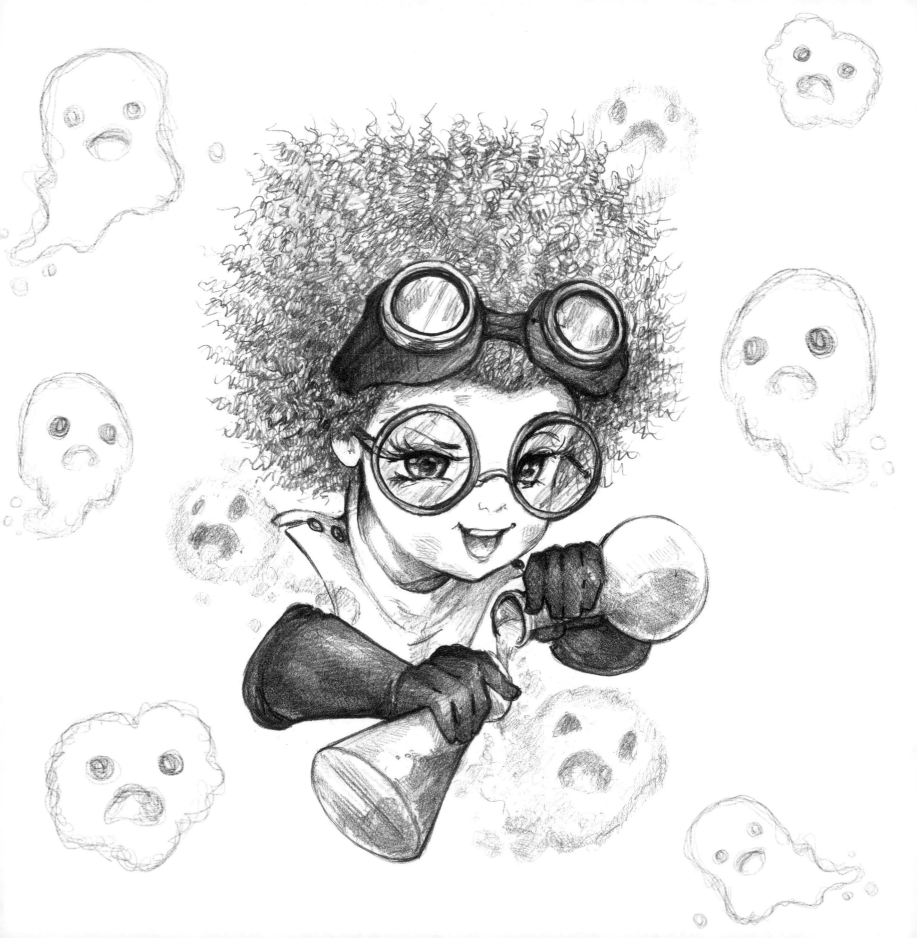

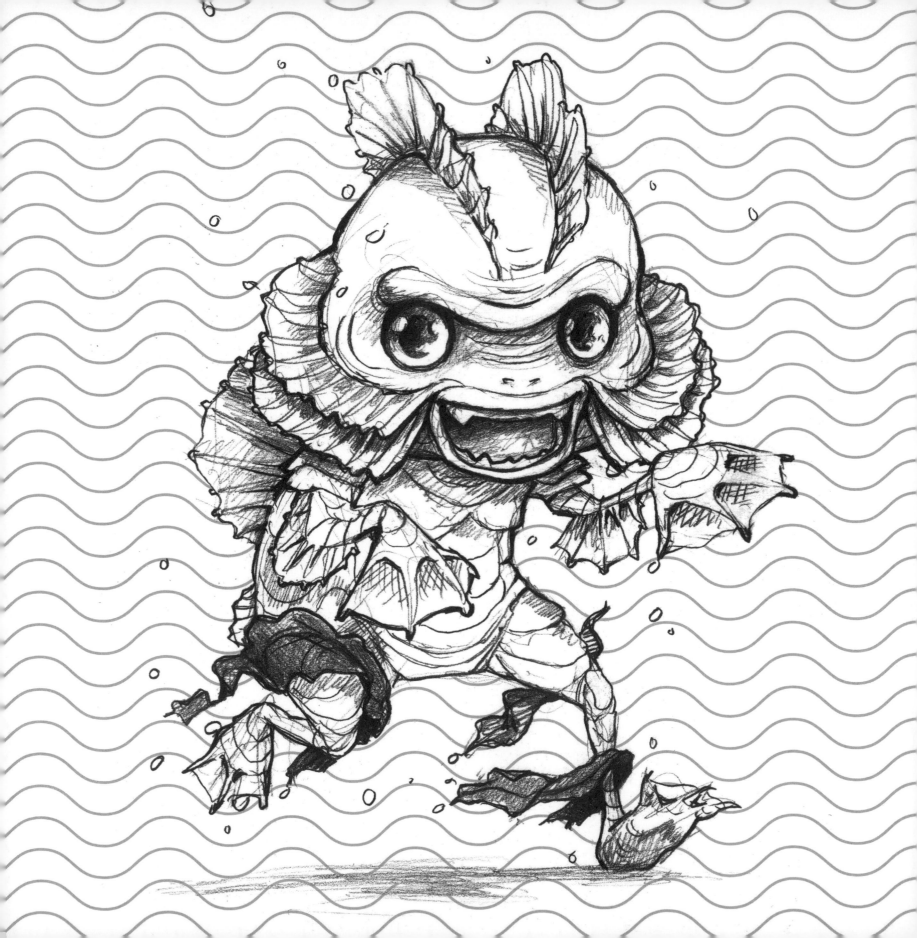

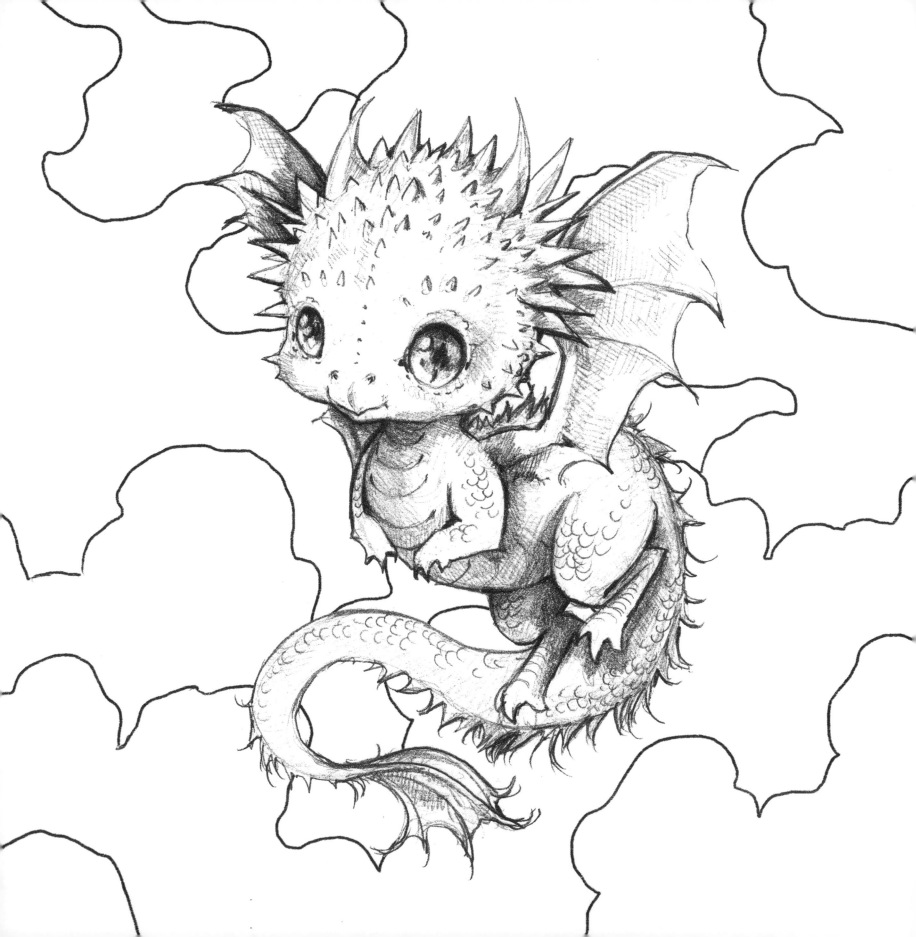

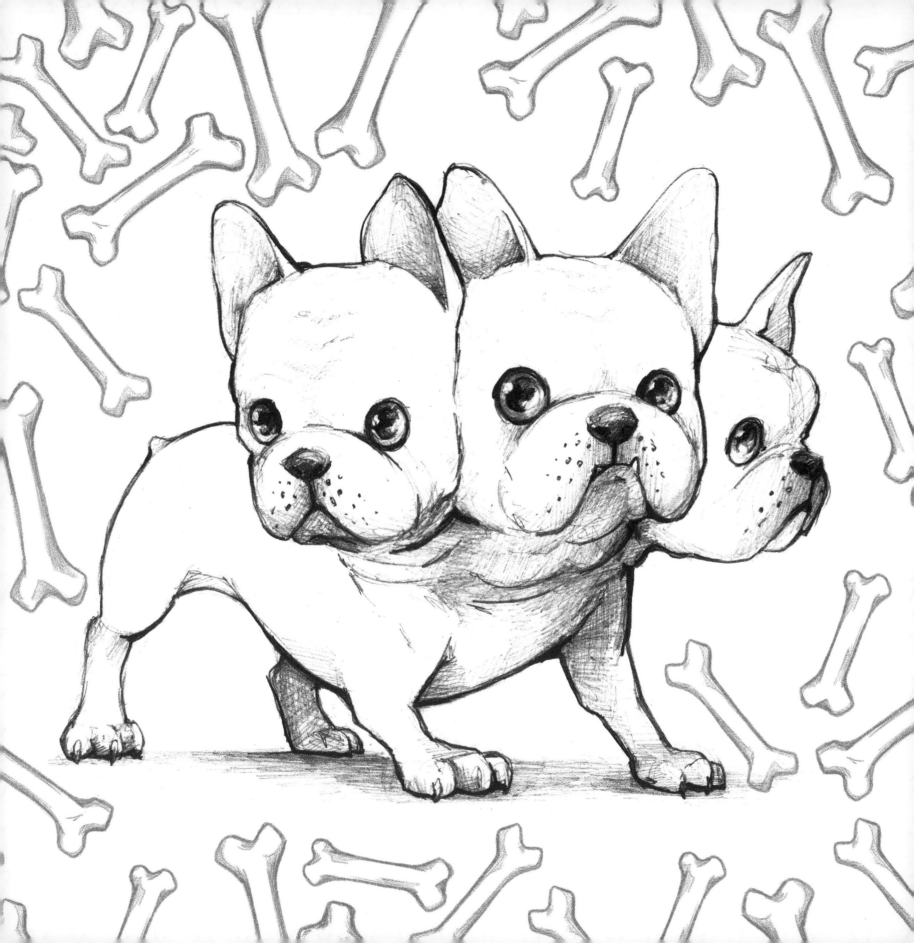

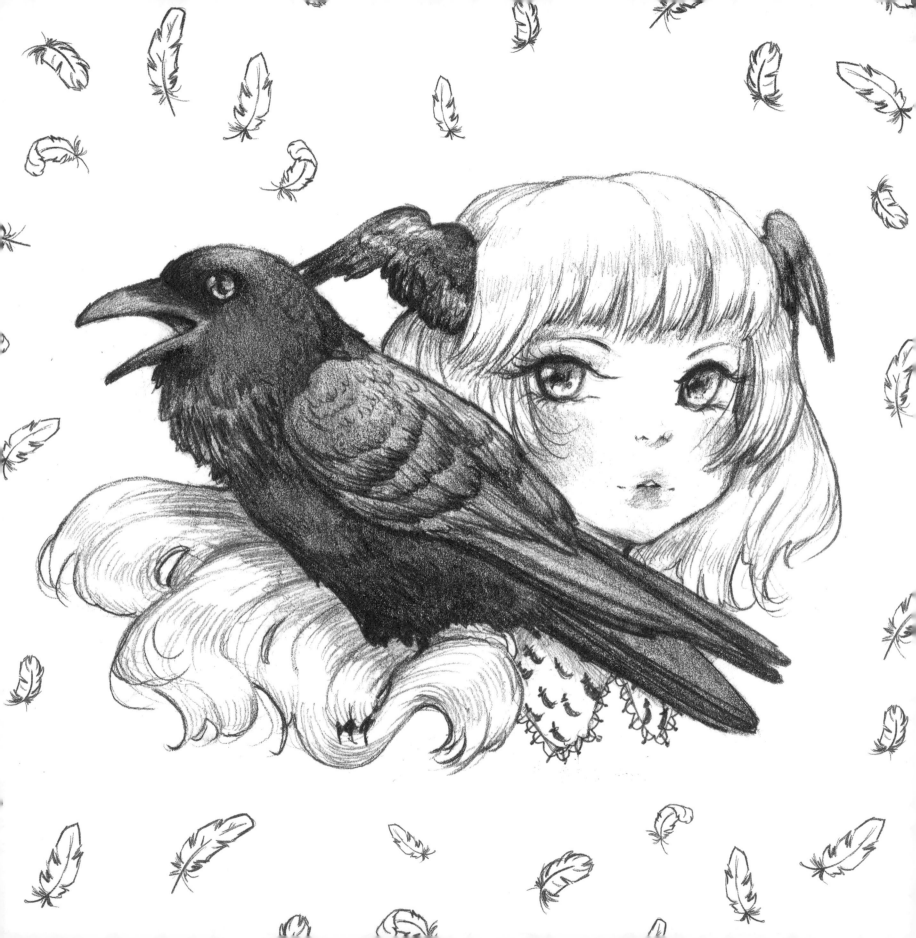

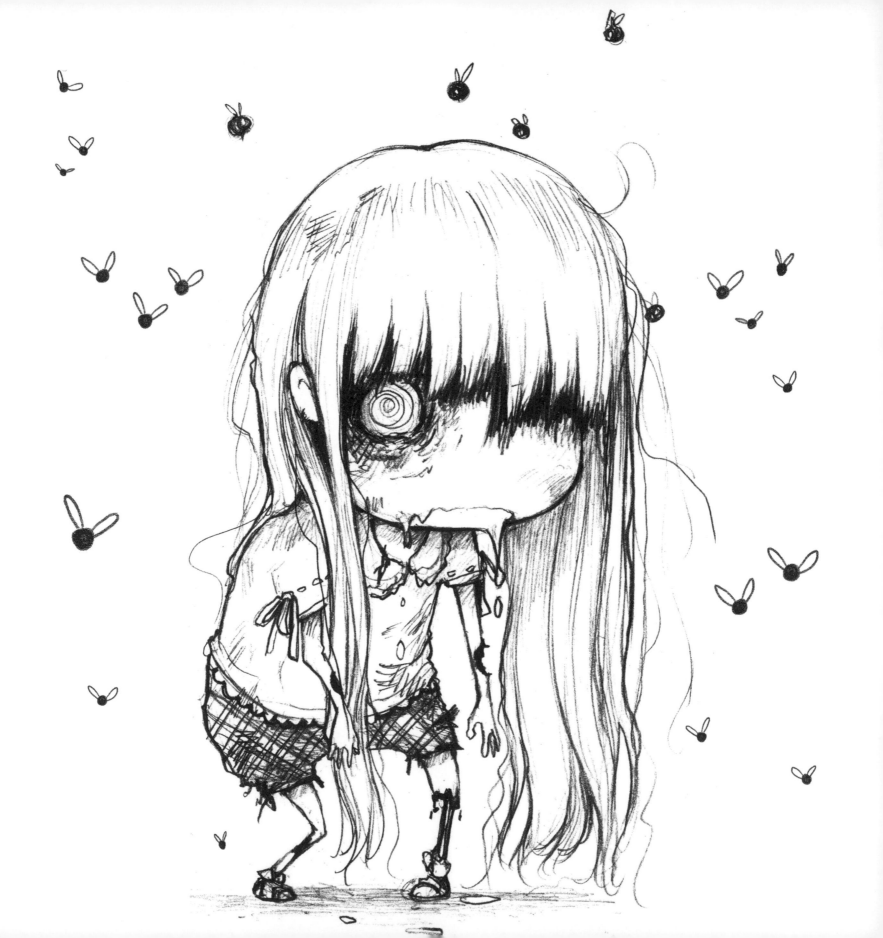

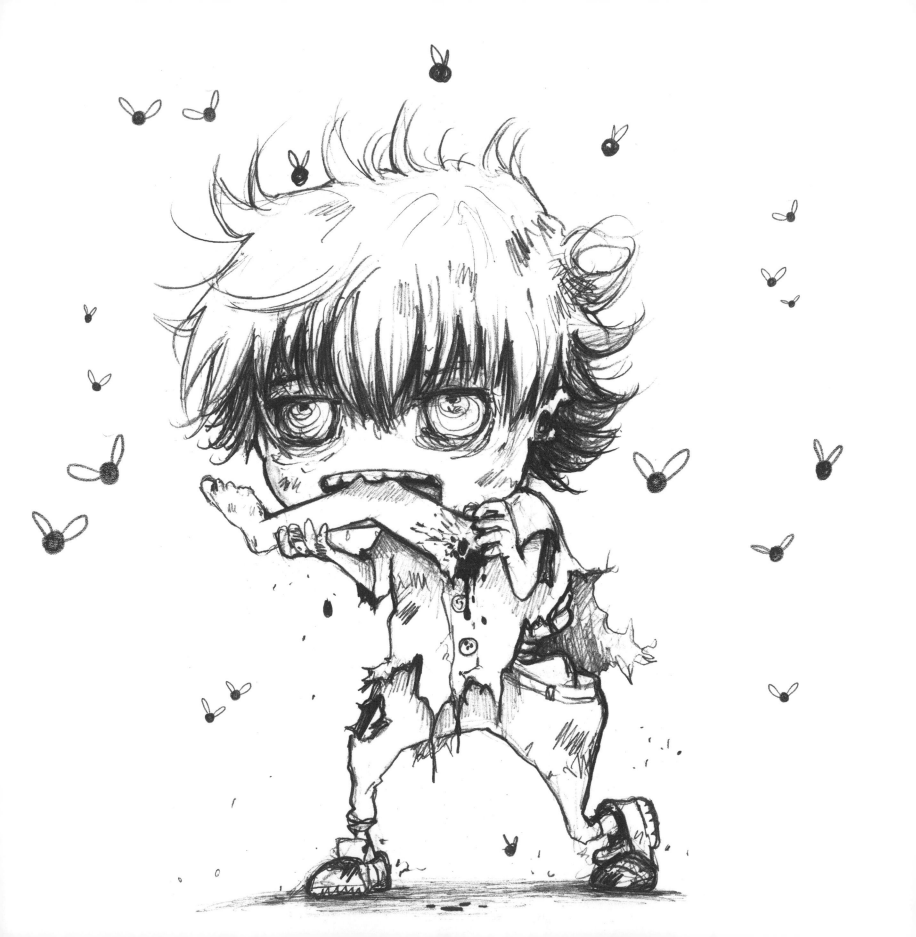

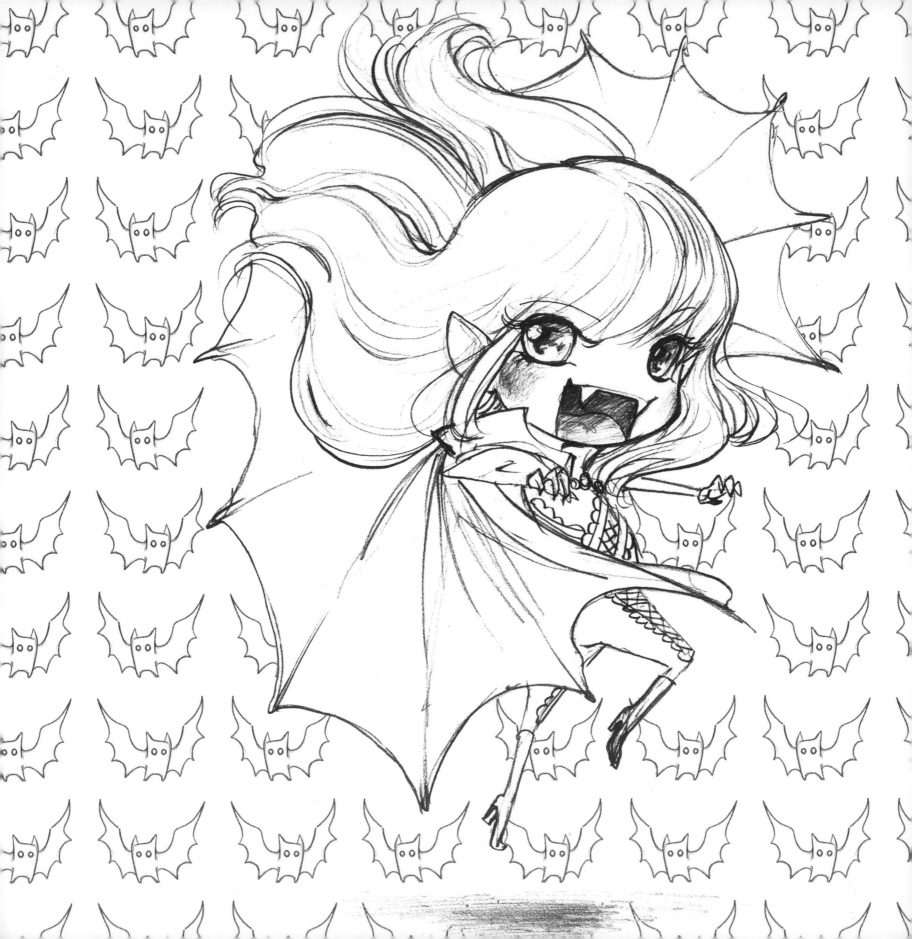

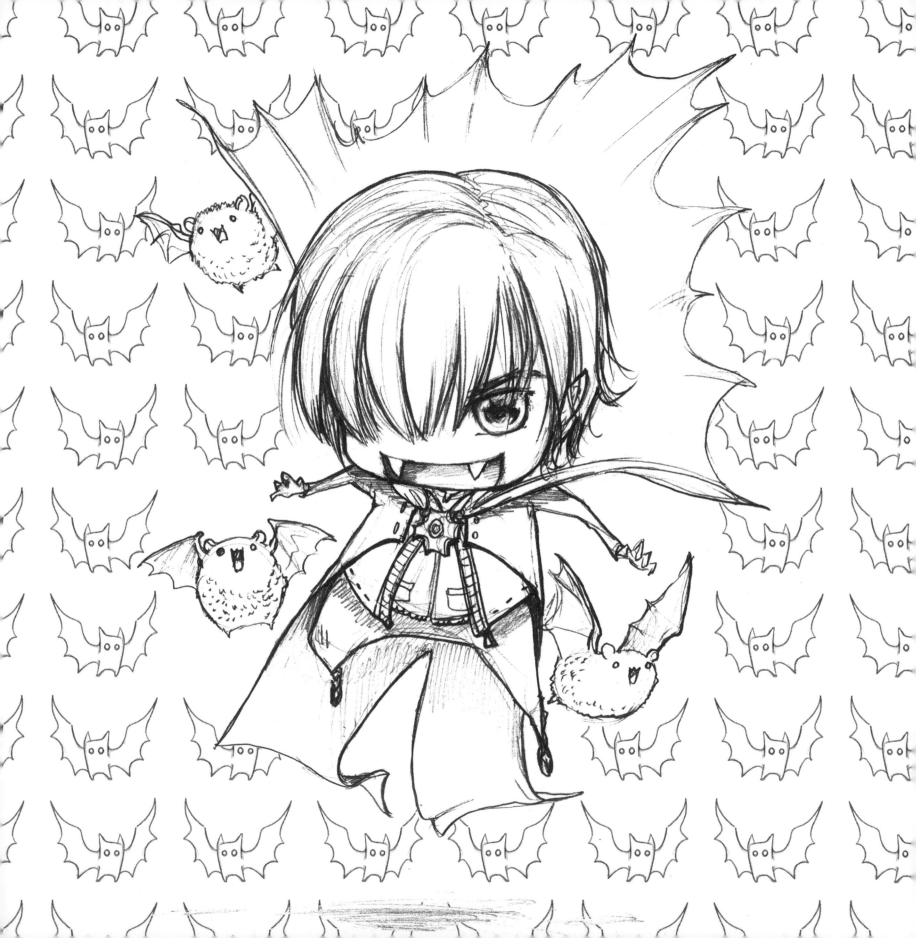

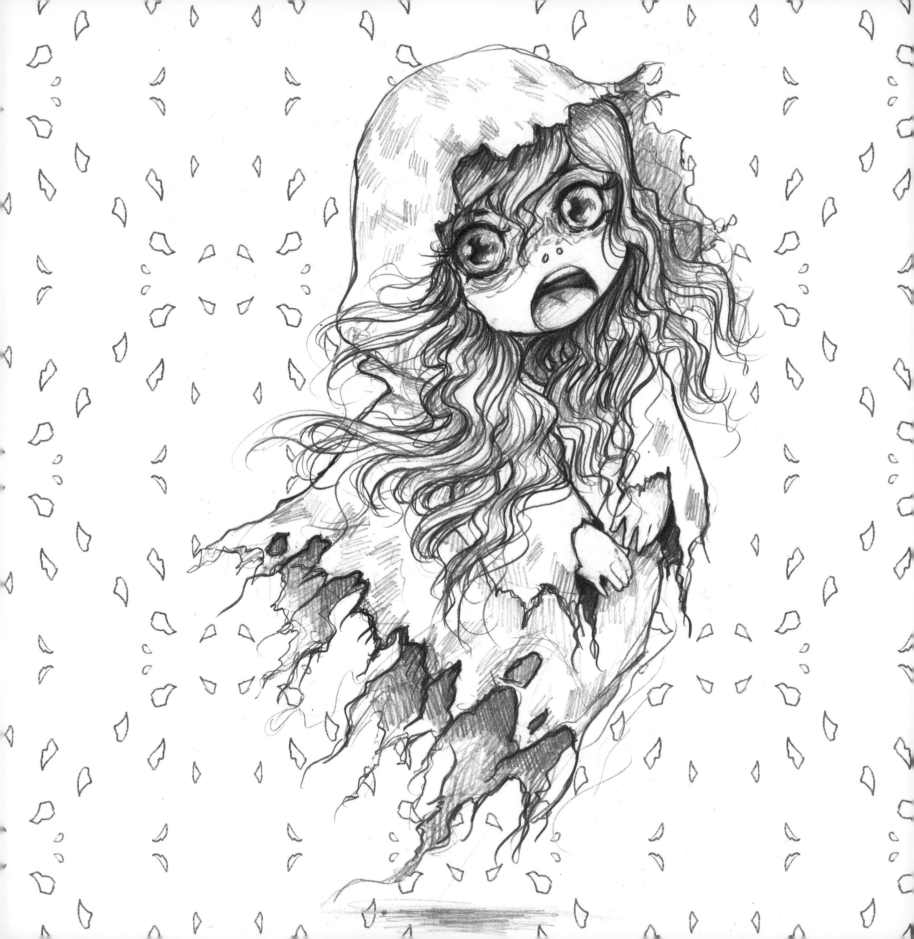

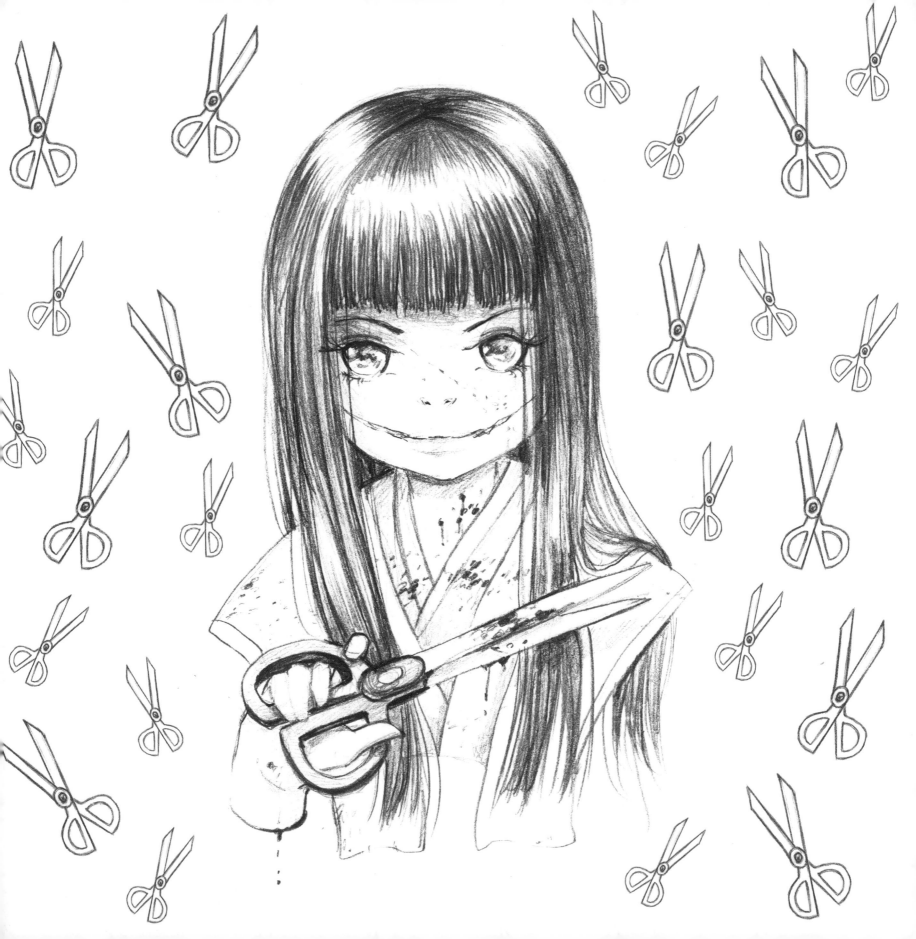

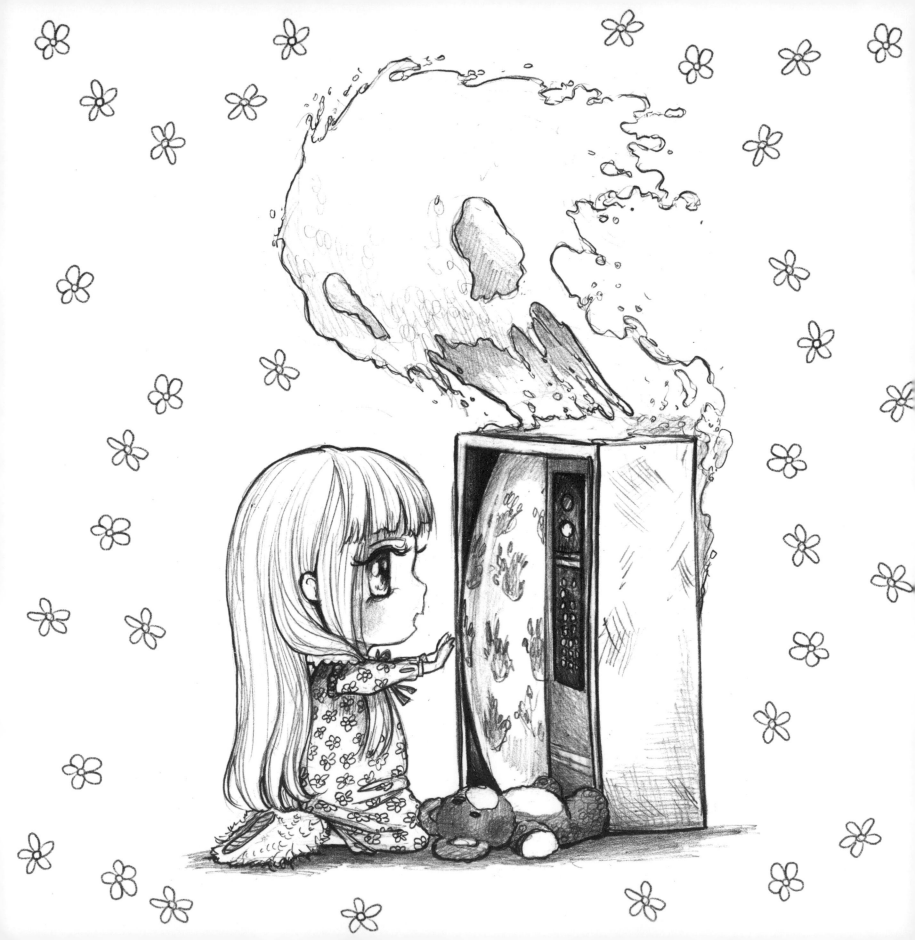

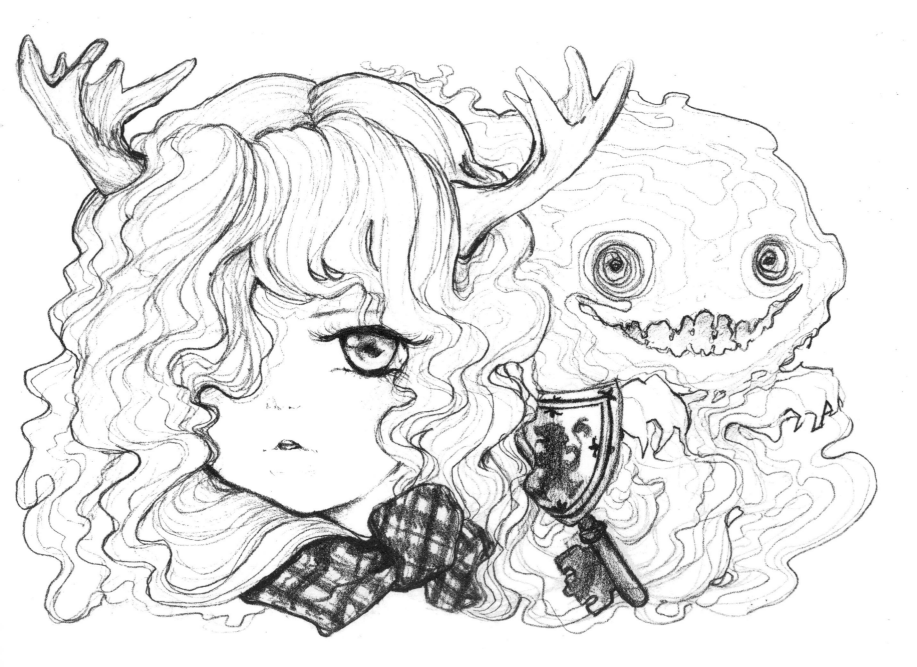

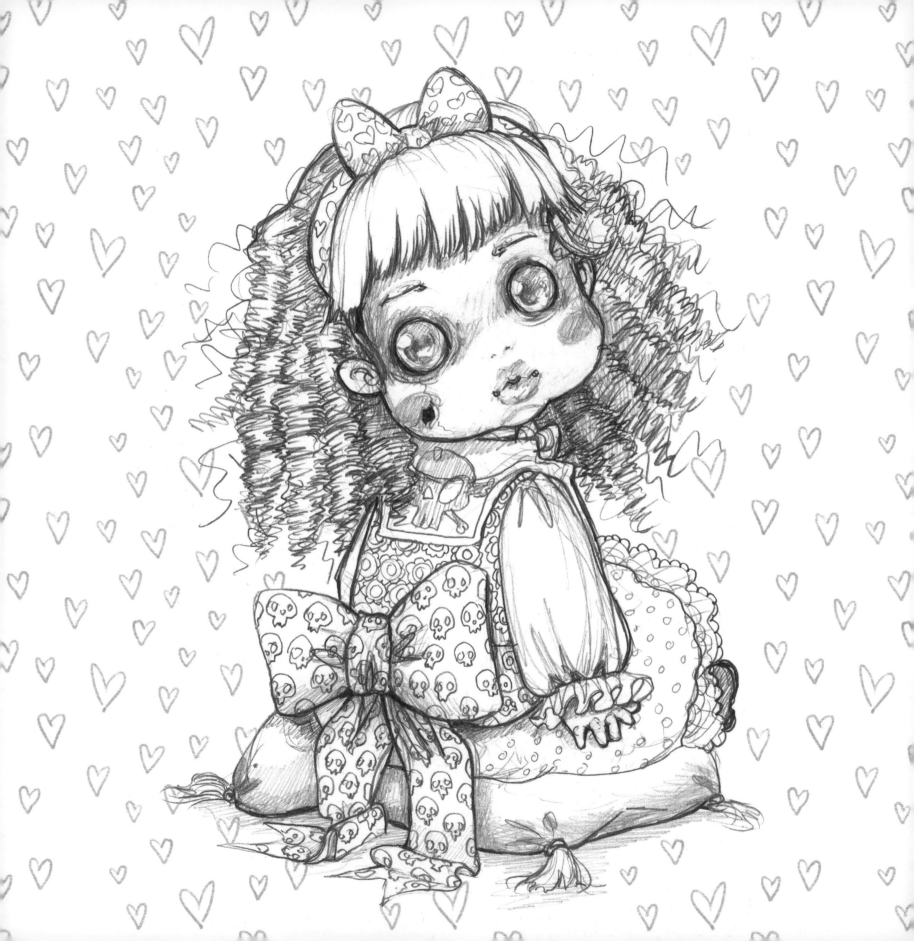

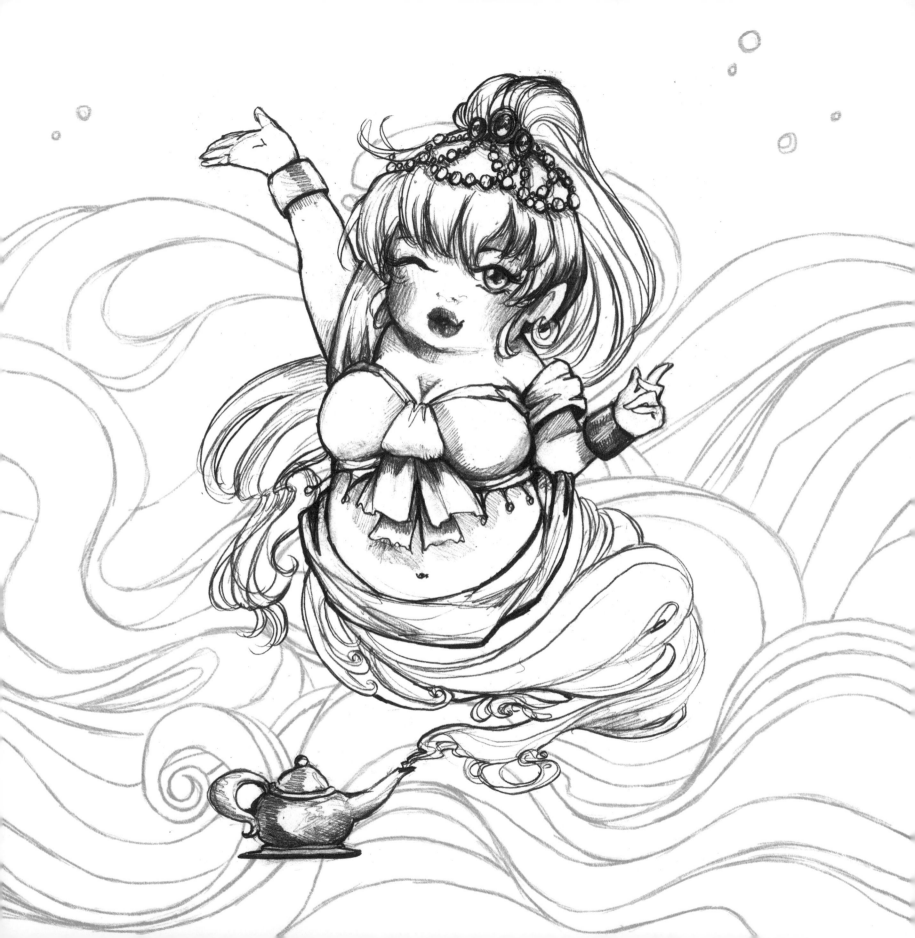

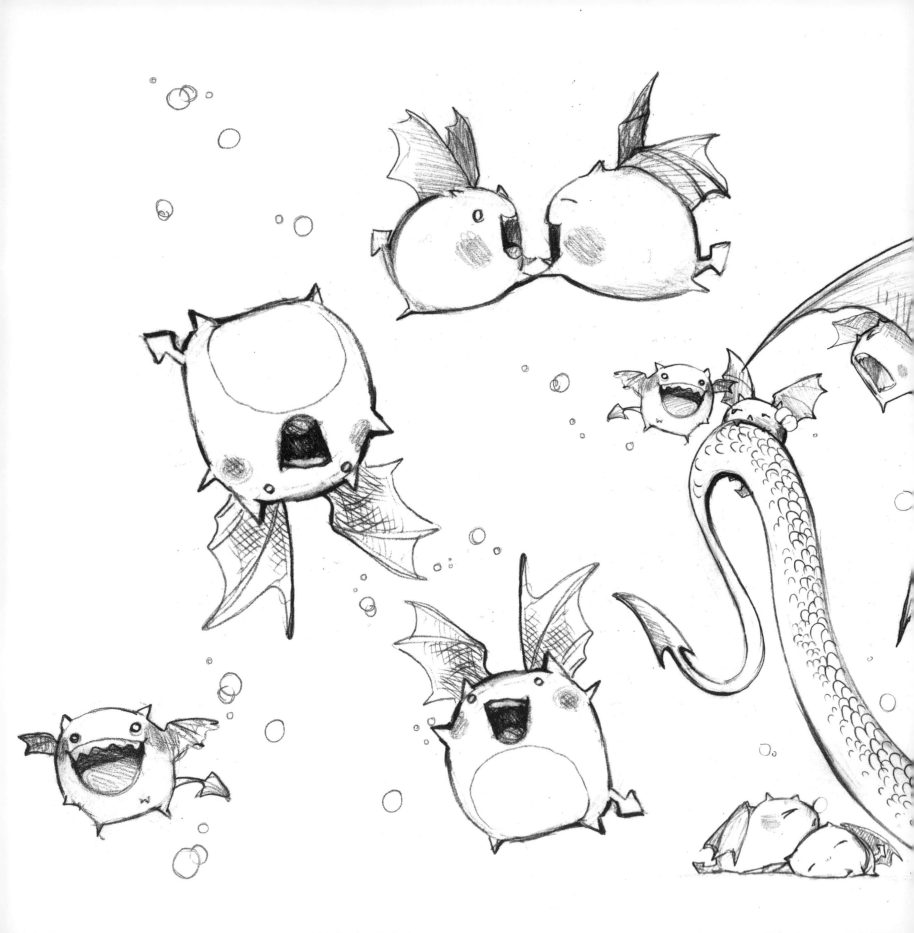

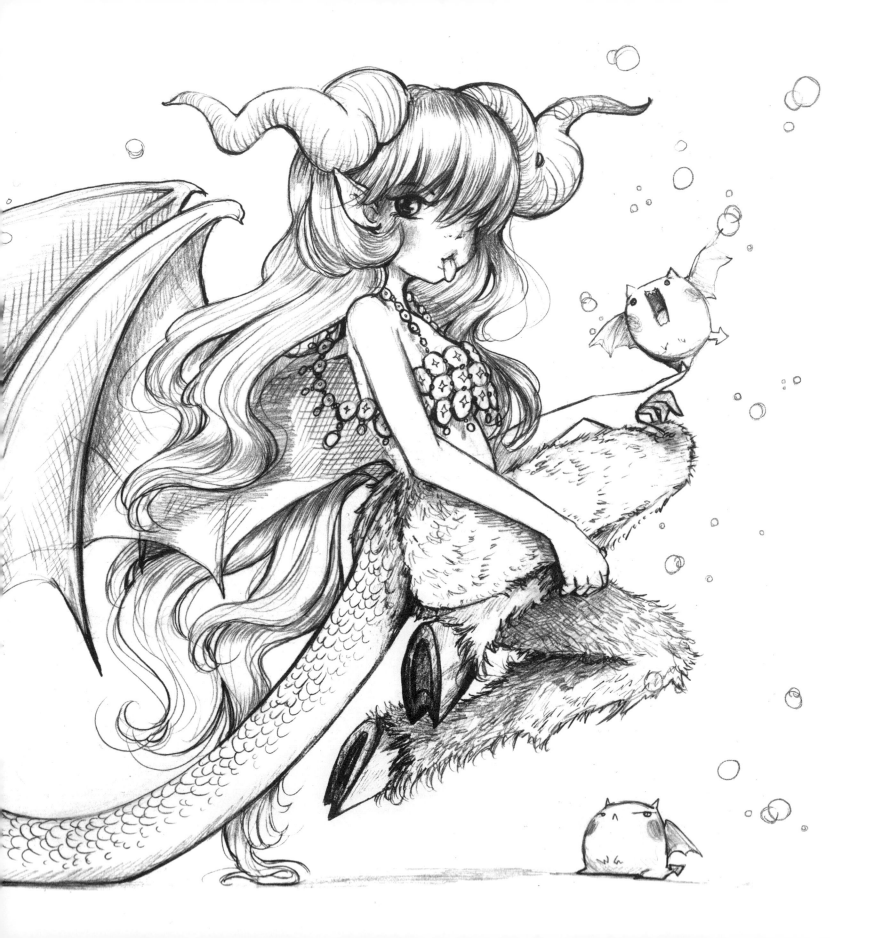

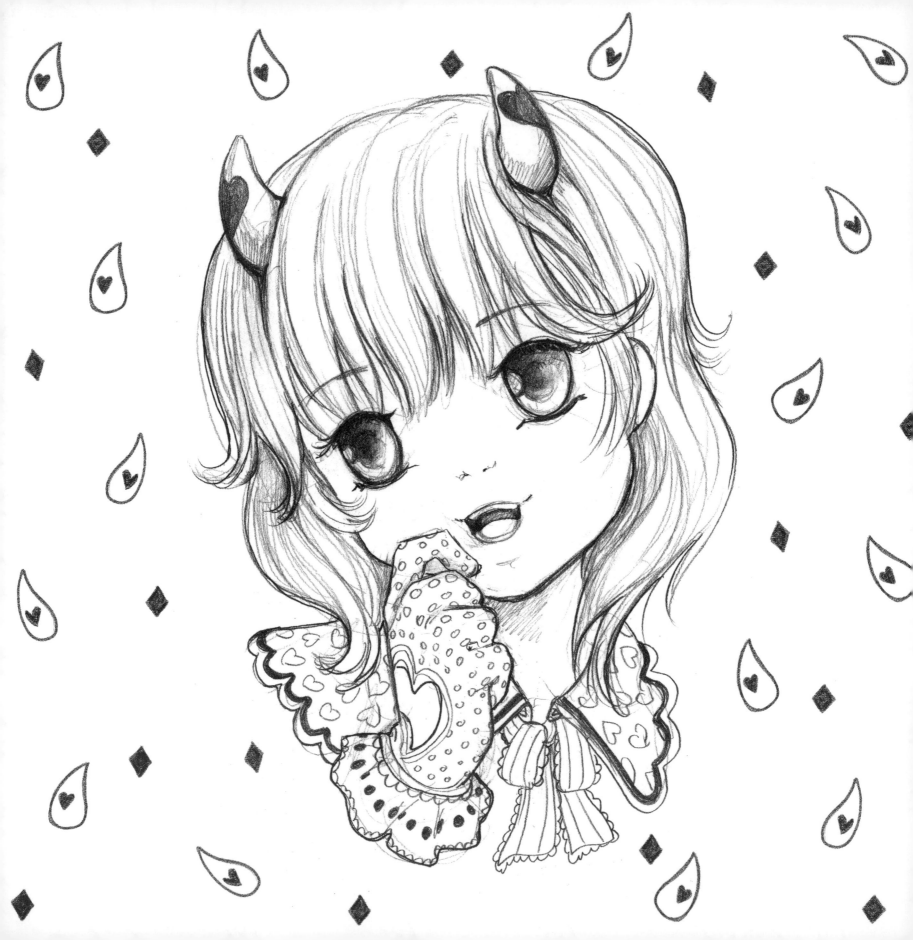

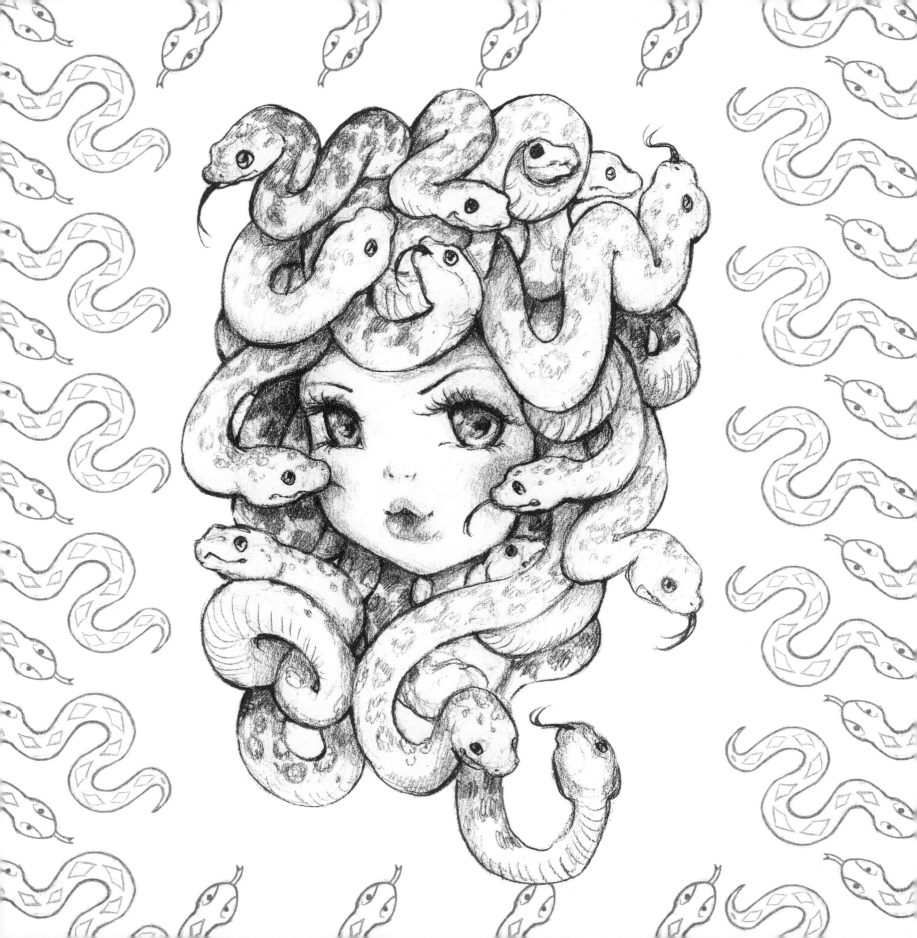

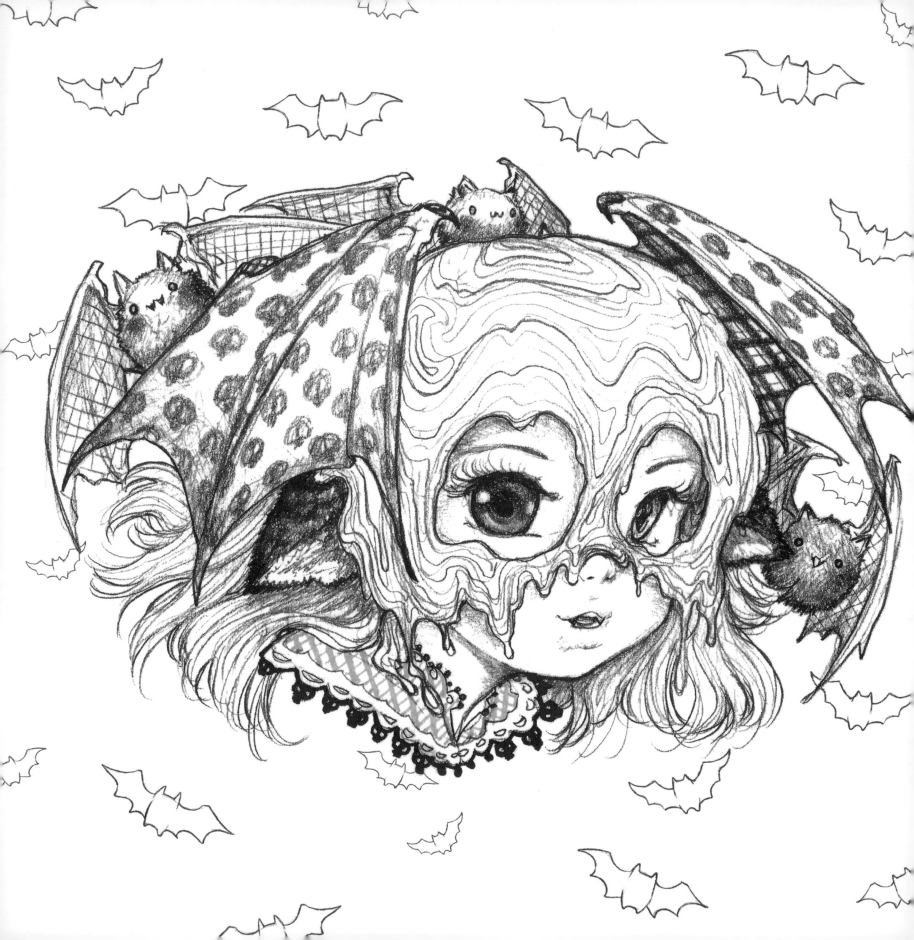

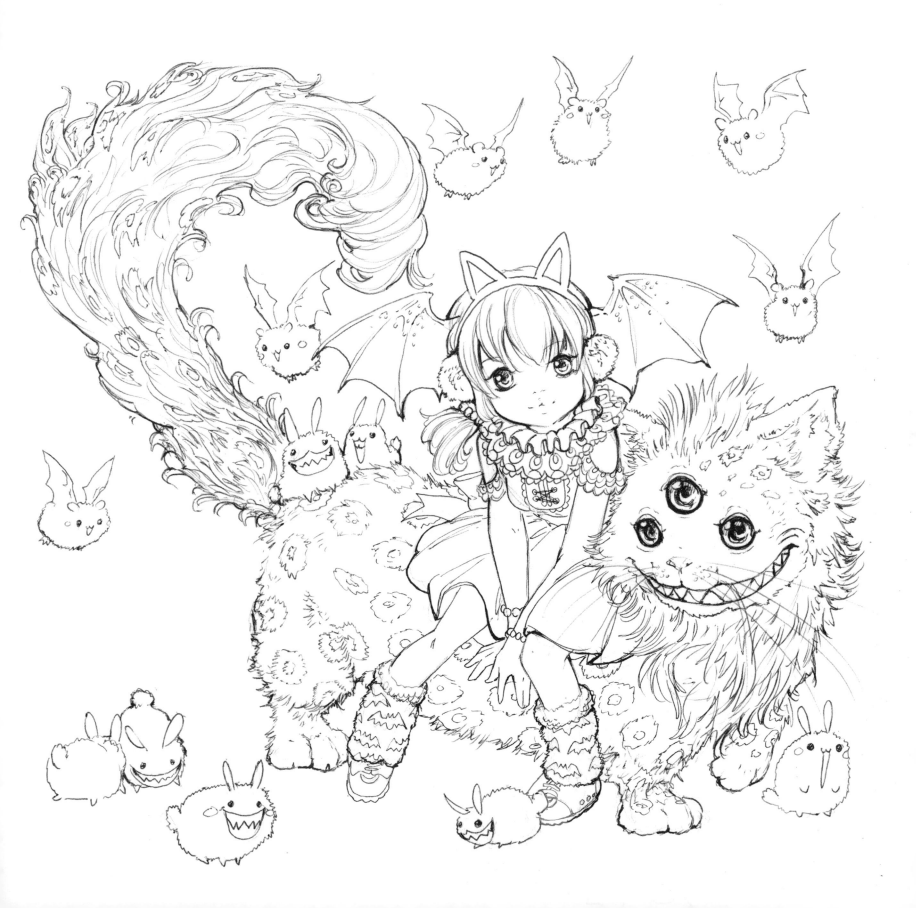

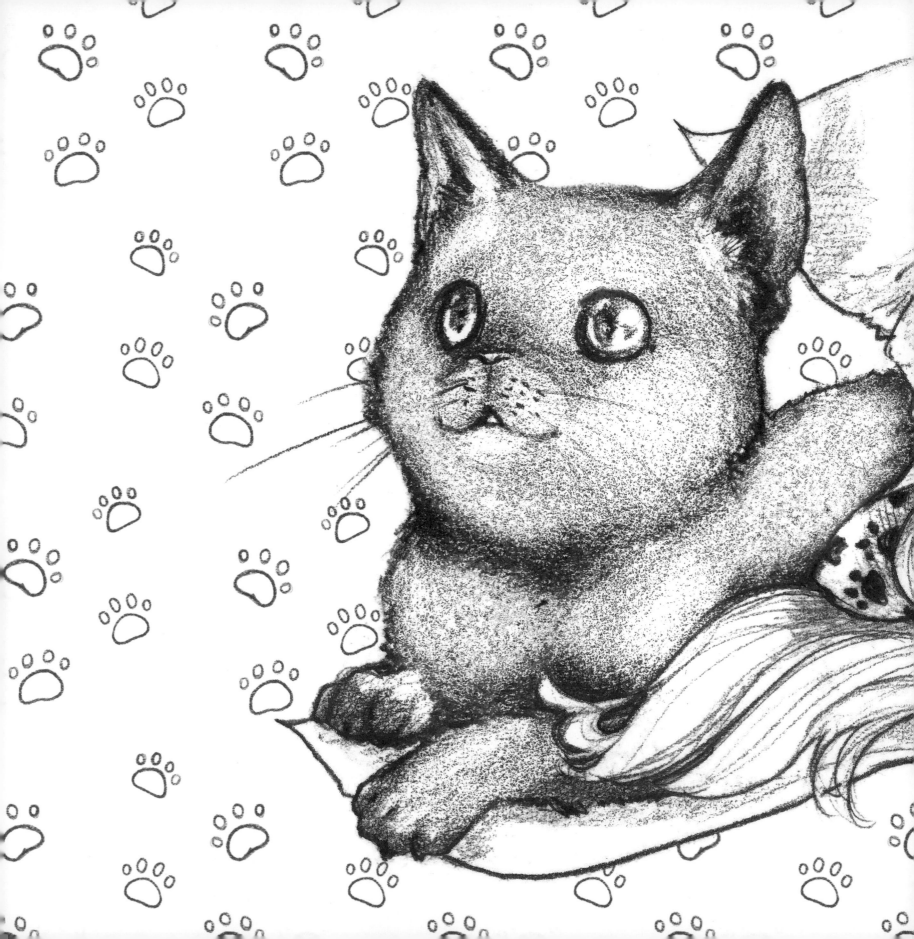

Printed in China

Design by Chloe Rawlins and Lauren Rosenberg

14

First Edition